Tips and Tricks for PaintShop Pro

Tips and Tricks for PaintShop Pro

Carole Asselin

Text and Illustrations Copyrights © 2019 Carole Asselin

All Rights Reserved

ISBN: 9781687409669

Table of Contents

Table of Contents ... 5
Introduction ... 7
The Author .. 9
Tools .. 11
Text and Fonts ... 57
Shapes and Drawing ... 71
Adding and Removing Elements 75
Files ... 79
Workspace ... 85
Keyboard and Mouse .. 103
Palettes .. 109
Menus .. 127
Colors and Textures .. 131
Content and Supplies .. 151
Preferences ... 161
Technical Considerations ... 171
Troubleshooting .. 179
Conclusion .. 191
Credits ... 193
Acknowledgments .. 195
Index .. 197

Introduction

PaintShop Pro has been a graphics program available for over two decades now. It is a powerful program that includes a multitude of commands, tools and features.

Whether you are a graphic artist, a photographer wanting to edit portraits and landscapes or a scrapbooker creating memories to print in a photo book, you always want to do things fast and simply. Despite being extremely powerful, PaintShop Pro is also a fun program that is fairly intuitive to learn.

At first, you either started by following tutorials you found online, or you just got right into it and tried commands, tools, buttons to explore their possibility, teaching yourself how to use the program. As time passes, each user starts becoming more and more comfortable in their own way to do things, their own workflow and the sequence of steps and the tools they use most.

This collection of tips can include some tools, effects and commands that you are already familiar with, but you may also discover a few ways to achieve effects, or execute steps in a faster and simpler way. Who knows? Maybe you will find ways to use your program that you never dreamed of!

The tips included cover a wide range of PaintShop Pro versions, from the old JASC versions to the most recent version which is, at this time, PSP2020. Some tips will only apply to older versions, some to only newer ones, and occasionally, a tip will be about a single specific version.

This book is not meant to be a how-to book or a comprehensive manual for PaintShop Pro. It assumes that you are at least familiar with the program and its main components and tools. It is meant to make your existing workflow faster and more accurate. You will not find detailed tutorials on

how to edit photos or create a collage or design a logo. This is not the intent of this book.

Although I discovered most of those tips working on scrapbook projects, they are not specific to that kind of work with PaintShop Pro. You can often use them in various graphics projects like photo editing, photo collage, card making, poster creation even painting.

Happy reading.

The Author

My name is Carole Asselin and I am a PaintShop Professional. I have been an active PaintShop Pro user since 2003. Although I have been specializing in digital scrapbooking, scripting and picture tubes, I have also been teaching PaintShop Pro to other enthusiasts who have gone on to do more than scrapbooking.

I have contributed to webinars, blog posts, tutorials and products for the Discovery Center from Corel since 2013.

I started with version 7, from JASC and looking for tutorials online, I could not find much so I explored the program by myself. Over the years, I have upgraded to each subsequent version up to the current version, PSP2020. This allowed me to discover various shortcuts, settings and tricks that I wanted to share with other PaintShop Pro users whether they were beginners or advanced users.

In addition to the tutorials and webinars from the Discovery Center, I also teach on my own site, the Scrapbook Campus[1]. Despite the name, the content is not just about scrapbooking, although this is the type of projects used to teach PaintShop Pro. In addition, I also have an online store, Creation Cassel[2], where scrapbookers, designers and photo editors could find tools especially designed for PaintShop Pro.

[1] https://scrapbookcampus.com

[2] https://creationcassel.com/store

Tools

PaintShop Pro is a complex program that includes a variety of tools to perform many tasks. Each tool has its own settings and ways to work and there are always some tiny details that could either make you waste your time, or save some.

Pixels Are Square

If you zoom in a LOT, you will see that every pixel is square so it is hard to get a smooth edge if it is not perfectly horizontal or vertical, so how do you get an edge, as smooth as possible on other edges? Try the **Smooth** command under **Selections > Modify > Smooth**. It will not cut the pixels differently, but will allow the edges to incorporate some fainter pixels to give a smoother overall look.

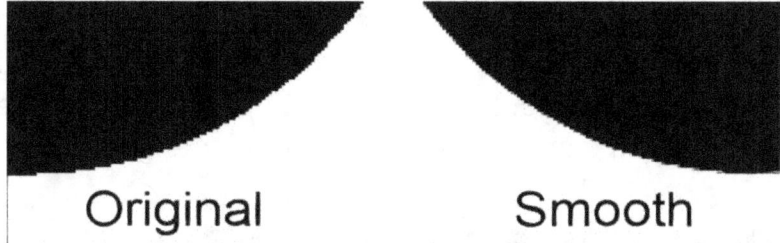
Original Smooth

However, remember that the pixels will still stay square!

Creating Straight Lines with Various Tools

If you were using a pencil and paper to draw, you would have a straight edge at your disposal, whether you needed horizontal, vertical or diagonal lines, or lines at any angle for that matter. In PaintShop Pro, you don't have that physical ruler on hand, but there is a simple tip to create straight lines, in any direction: the **SHIFT** key.

Let's assume you want to use the **Brush** tool to draw some straight lines. Once your tool is active, click on the starting point, hold the **SHIFT** key, and then click on the end point. In addition, you can keep holding the **SHIFT** key and click multiple times to create a series of consecutive straight lines, like cutting around an image or a drawing a "point-to-point" design. Depending on the **Step** size of the **Brush** tool, you might have a solid line (with a **Step** of 1) or distinct shapes (with a **Step** of 200).

This tip might seem obvious to apply to the **Brush** tool but you can use it also for the **Eraser** tool, the **Color Replacer** tool, the **Smudge** tool, the **Push** tool, the **Warp Brush**, and more.

Let's try with the **Eraser** tool. Set the **Step** to 200 and choose a round tip. Click on the left end of a straight edge, hold the **SHIFT** key and click on the right end. This will cut out identical shapes with perfectly even spacing along an edge, like the teeth of a postage stamp for example.

You can use this tip to create "straight lines" in any direction, whether it is horizontally, vertically, diagonally or anything in-between. So, remember that, it will make your work straighter!

Resizing Correctly with the Pick Tool

Whenever you have to resize an element, or a photo, you might want to use the **Pick** tool (or the **Deform** tool for versions before X). It is easy and quick. But using it can cause some unwanted distortion if used incorrectly. The image or element could become too thin or too thick and really look bad.

There is a very easy fix: first, make sure the **Mode** is set to **Scale**.

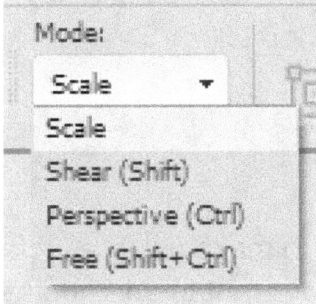

Once the tool is activated, you will see 8 handles around the element on the layer.

You need to use one of the corner handles to resize the element and maintain the proportions. If you use the handle on the top, the bottom or one of the sides, it will override the "Scale" setting and will distort your element or your photo.

In versions 9 and before, using the corner handle does not maintain the proportions but if you use the right-click while holding and moving the corner handle, it will work just as well. In versions X and above, the simple **Mode** setting will be enough. This will keep the element or the photo proportioned correctly. So, no more excuse having Aunt Lucy look 50 pounds heavier or 6 inches too tall!

Edit a Selection

Simple selections are easy to make using a rectangle or a circle for example, but sometimes, you want to add another section to the selection or remove a bit. This can also apply to the **Freehand Selection** tool or even the selection done with the **Magic Wand**. If you want to add to the selection, you can change the **Mode** to **Add**, and if you want to remove some parts, you can change it to **Remove**.

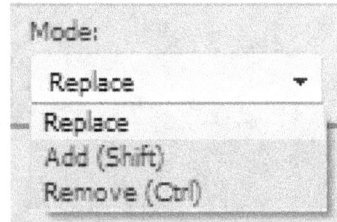

However, notice that there is a shortcut beside the **Add** and the **Remove** mode. So, in order to save time, instead of changing the **Mode** in that dropdown list every time you want to add or remove a section, simply use the **Shift** or the **Ctrl** key. This is just one key to hold while you keep working with the cursor for the Selection tool of your choice.

How to Move a Selection

Selecting a rectangular area with precision is fairly easy but if you want to have a selection of a different shape, like a circle, it might be hard to "aim" at the right place. There is a very easy way to do that.

Select the area of the size and shape you want as close to the actual location that you want. If the object you want to feature is not at the right location within the selection, simply MOVE the selection. Notice that while your cursor is inside the selection, it changes shape as a **Move** cursor (a four-point arrow). That means that if you use your right-button, you can grab and move that selection more precisely. Of course, you can also use that method to move a rectangular selection if you find your subject is not where you want it to be. It is surely very useful and quick!

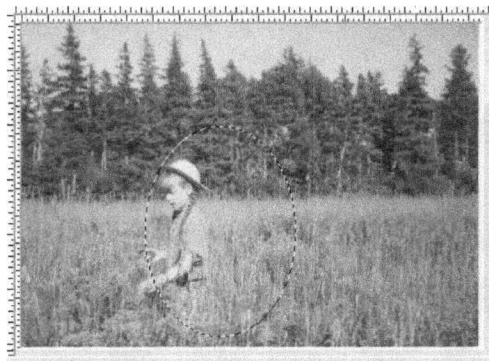 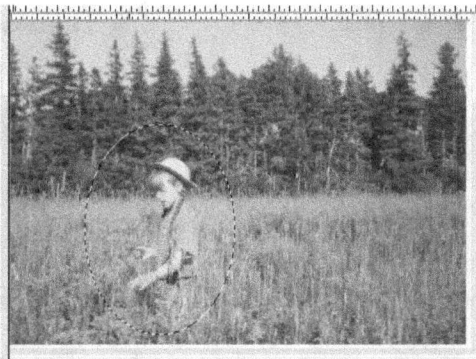

Another method is to use the **Edit Selection** command. You can find it under **Selections > Edit Selection** or using the icon in the **Layers** palette. The icon has slightly changed over the various versions.

Versions 8 – X4

Versions X5 - 2020

This will turn the selection into a reddish area that can now be manipulated just like an element on its own layer: you can move it with the **Move** tool, but you can even resize it with the **Pick** tool (or **Deform** tool in earlier versions). When it is where you want it, click on the **Edit Selection** again and the reddish layer will disappear, leaving the familiar marquee where you moved it.

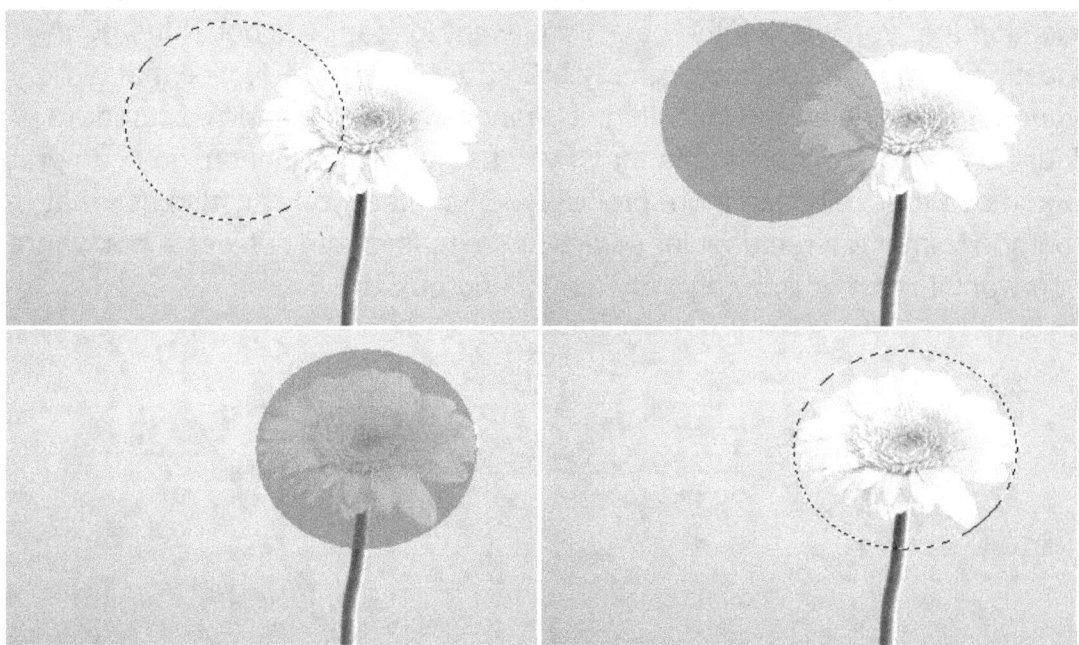

Edit a Selection Again

Sometimes, a simple selection is not enough and tweaking it by adding or removing sections would be either too complicated, difficult or just a waste of time. But using the **Edit Selection**, that new selection can be treated just like an element on its own layer; you can manipulate it with the **Pick** tool to resize it, reshape it or rotate it, but you can also apply other distortion effects, like **Wave** or **Twirl** for example. This is how you can modify the selection to make something that would otherwise be just about impossible to make.

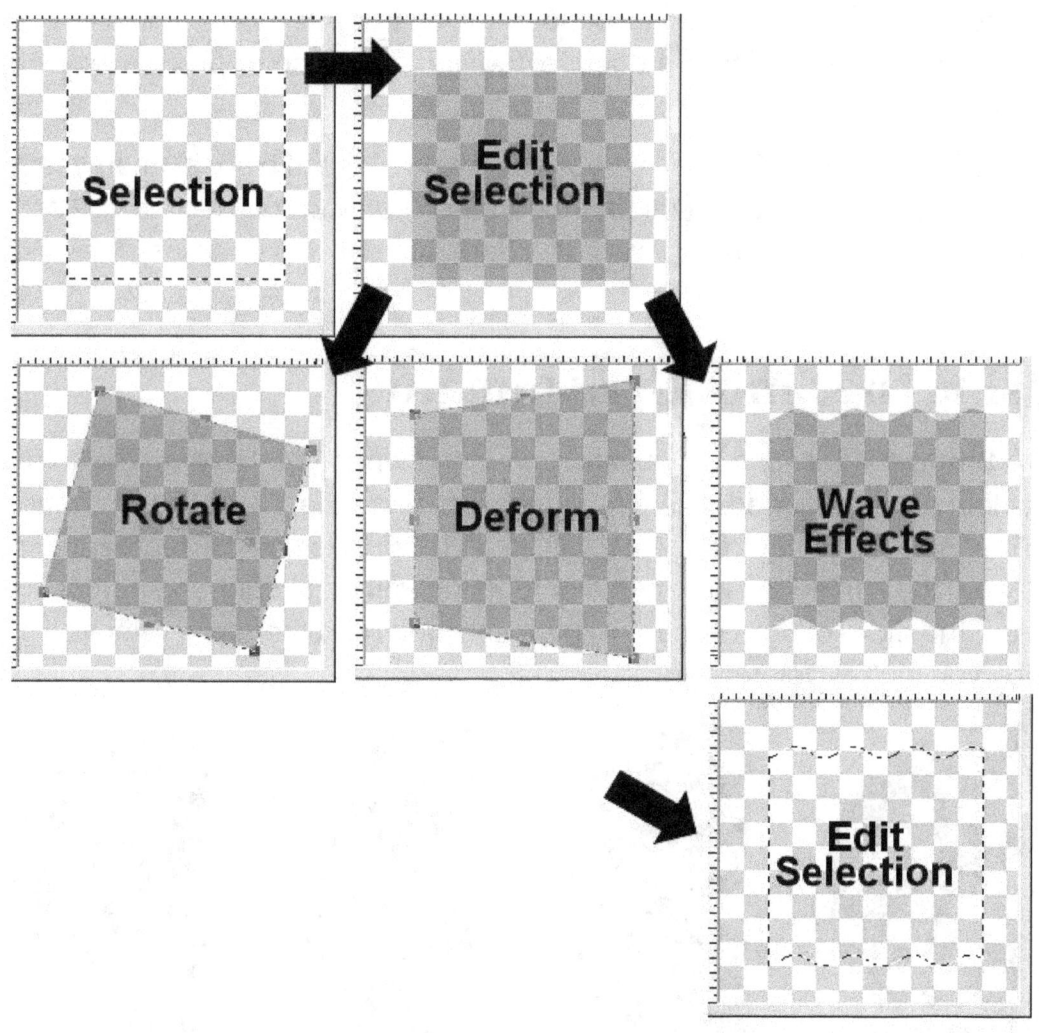

Zooming Faster to See Better

Some tasks will require the user to zoom in closer to either see details or place an element precisely. There are a few ways to zoom in or out, but one of them is much faster than any of them: use your mouse wheel. If you are using a graphics tablet, there should be either a button or another element that will emulate that mouse wheel.

You can then zoom in and out in a fraction of the time it would take to go click on the zoom button or even the keyboard shortcut to activate the tool.

In fact, it allows you to zoom in without having to switch tools which is another time saver if you are doing extraction, selection or precise drawing. Try it.

One additional tip: if you place your cursor in a specific position on your image, the zooming will focus on that area so you won't have to scroll as much to find the section you wanted to look at.

Using the Smooth Command

The **Smooth** effect is a very useful command when you have a selection that looks a little jagged. It is easy to correct since the **Smooth** command will do just what it says it does: it will smooth the selection by feathering it a bit, and you can adjust how much smoothing you would get; the higher the value, the more of the element will get selected (and therefore removed once you hit the Delete key).

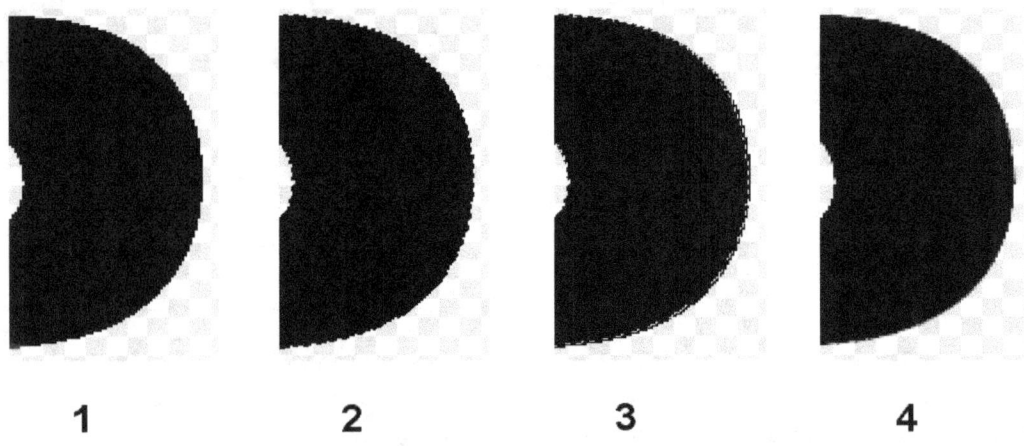

1 2 3 4

First, you can see that the edges (often on curved areas) are jagged (1). Select outside of the area you want to smooth (2). Going to **Selections > Modify > Smooth,** you can set the amount of smoothing; the higher the value, the smoother the edge will be, but at the same time, the more it will remove on the edge. You should then see where the new selection will be (3). Hit the **Delete** key on your keyboard to remove all that is now "extra", and once you deselect (**Ctrl-D**), you will have a smoother edge than what you started with (4).

This is a very useful tip to use when you want to extract elements.

Beware that there is also a setting for corners. It will allow you to keep corners as they are or round them off. If that box is unchecked, all the corners will be rounded. It is up to you to decide if that is something you want or not.

Also, since you do want a smooth edge, make sure the **Anti-alias** is checked.

Using the Warp Mesh

The **Mesh Warp** tool allows you to warp an element using a grid of nodes. The grid can have up to 31 columns and 31 rows of nodes that can be moved independently or in groups. Once you have carefully adjusted the **Mesh Warp** to achieve the shape you want, you can apply it by clicking on the Checkmark in the **Tools** toolbar but you can also save that new mesh as a preset to be used again.

Just like most tools in PaintShop Pro, you can save your work as a preset, name it in a way you can remember what it does and use it again on a different project.

Did you know that if you created a mesh on a square image, you can apply it on a rectangular image and vice versa? In fact, the mesh is a set of nodes placed proportionally according to the size of the image. So from now on, if you work hard on a particular mesh to create a specific end result, just save

it as a preset: you might find times to use it later.

One tip to remember: when you want to save a mesh as a preset, save it BEFORE you apply it to your current image. If you want to test it before, go ahead, then undo the "Apply" command, so you can save the preset.

Drawing with the Pen Tool

The **Pen** tool allows the user to draw a variety of lines, whether they are straight or curves. Although using the **Lines** mode yields a clean result, using the **Freehand** draw is quite a different story. We might expect that the **Pen** tool will allow to draw smoother lines than you could get with the **Brush** tool but it is common to end up with a choppy line. In fact, every tiny movement of the cursor will yield a node, and unless you are a perfectly programmed robot, you will likely end up with dozens if not hundreds of nodes on the path. How would you handle so many nodes?

In order to reduce the number of nodes, check the **Tracking** value. Increase it to at least 50. Then, when you use the **Pen** tool in **Freehand** mode and "**Create as Vector**" is checked, along with "**Show nodes**", you should see a better result.

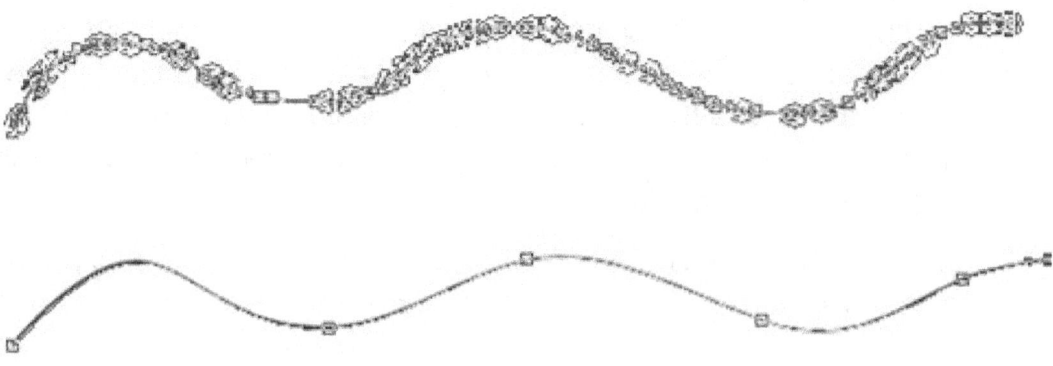

This will reduce the number of nodes you will get. That way, instead of turning every single move and twitch into a new node, it will use fewer nodes which will yield smoother lines and a more manageable number of

nodes to edit. Of course, it will not draw for you (I wish it did), but it will make your hand movement appear smoother.

Placing an Element Exactly in the Center

For some projects, it is necessary to place an element or an image exactly in the center of the actual project. Of course, you could set guides, horizontally and vertically, and have the element snap to them but there is a much quicker way: copy and paste. If you copy and paste an element as a new layer, it will automatically land in the very center of your image, without fail. So, if you want some elements to be layered all centered like a flower, simply copy and paste them one by one and then, link the layers. Once done, you can move them all around and still have them perfectly overlapped.

Using the Same Brush Tips for Other Tools

By the name, we could expect the brush tips to be used with… the **Brush** tool. That is a given. However, those "tips" can also be used with many other tools. You can use them also as "eraser tips" which makes sense, but also MANY more tools. In fact, you can use your brush tips for regular **Brush**, **Airbrush**, **Lighten** or **Darken**, **Hue change**, **Saturation chang**e, but also with the **Clone**, **Burn**, **Emboss**, **Smudge**, **Sharpen**, **Soften** tools.

Not all the brush tips are that useful with all those tools, but they are useable. Check them out. Play with them and you might actually find some unexpected yet interesting results.

Reset a Tool to Default

Sometimes, we might try to use a particular tool but its behavior is unexpected. Maybe the angle of the brush tip is off, or the blend mode has been changed. Some of those settings might have been modified by previously using a script that needed different settings, or maybe you used

that tool a while ago to follow a tutorial requiring those settings, or it is also possible that they were changed by an accidental click of the mouse. If there is only one setting to change, it is easy and fairly quick, but some tools will have many settings and it is not always obvious what they should be. Changing the settings one by one can be tedious or at least a waste of some of your precious time, especially if that particular tool has lots of settings to adjust (for example, the **Brush Variance Palette** has 21 possible settings).

If that is the case, there is a very easy fix. For most tools, there is a little icon like a half circle arrow hidden under the **Preset** icons. For the **Brush Variance Palette**, it is at the bottom of that palette.

That is a reset button. It will reset the values back to default with a single click.

How to Flood Fill with a Different Opacity

This tip will help you save some time, I promise. There are times when you might need to flood fill one section of an image, and have it at a lower opacity than the rest. If this should be on the same layer as other elements, it could be a challenge.

For example, if you are making a ribbon, a frame or something else, how do you get, a translucent center with opaque outside?

The traditional way would be to do the opaque section, add a layer, flood fill the new layer (in the area you selected), reduce the opacity of that layer, and then merge the two together. This requires more steps than necessary. In addition, you might not realize that the top layer will inherit the opacity level of the bottom layer, so you might end up with a change in the opacity, something you didn't want.

But there is an easier way. The setting of the flood fill tool has the option to set the opacity right before you fill. So you do NOT need to add a new layer

and then merge. You can create some neat elements with different opacity, quickly. Just make sure you reset the **Opacity** value back to 100 once you are done.

You can also use this tip if you want to paint with different opacities without having to use separate layers for each section.

Connect the Dots

The **Pen** tool in PaintShop Pro can be used for many things. Do you want to replicate a specific shape with a vector? Use the **Pen** tool set to **Draw Lines and Polylines** (in the **Modes** settings). Set a **Foreground** color but not a **Background** color (not yet anyways so it will be easier to see what you do).

Check the **Connect Segments** setting. By default, it is unchecked, which explains why many users don't know we can connect them. Now, you simply have to go click, click, click, click, just as if you were connecting the dots (remember those drawings we did when we were young?). No need to hold the mouse button or a keyboard key. Just click away until you get back to the start (if you want a closed path) or elsewhere.

Now, if you want to fill the shape, just add a **Background** color and you are done! It is still possible to edit the nodes afterwards, but it is a really good start that is easy and fast.

How to Grab and Move Tiny Elements

Normally, in order to grab an element from a project, clicking on it with the **Move** tool will be sufficient; the layer for that element will automatically be activated and then the element could be moved around. However, when the elements are very small (like text, or scattered elements), it is harder and a different layer might get activated (and moved).

There is a very simple way to catch those: hold the **SHIFT** key when the correct layer is active and like magic, the whole layer will move at once no matter where you "grab" it. Of course, it requires you to activate the correct layer first, but it will avoid moving the background layer instead.

Another use for this trick is to recover elements that seem to have moved out of the frame of the image since there is no way to actually click on them directly.

Using the Straighten Tool

It is common to have a photo that should be straight but the horizon is not horizontal and the water from the photo might leak onto the desk! Using the **Rotate** command might come to mind as a way to adjust that horizon but it typically does not yield a great result, because you might not know the exact angle the image needs to be rotated. Using the **Pick** tool is not better as it tends to not rotate in tiny increments so it is very imprecise.

There is an easier and even more accurate way to do so: the **Straighten** Tool.

You find that tool under the same icon as the **Perspective Correction** tool (under the **Warp Mesh** in version 9).

Here is how to use this tool. Once the tool is activated, a straight horizontal line with two handles will appear in the center of the image; move the nodes so that the line will follow the slanted horizon and then, click the **Apply** button. PaintShop Pro will do the proper calculations and rotate the image to make it perfectly horizontal.

Here is the line with the two handles as they appear when the tool is activated.

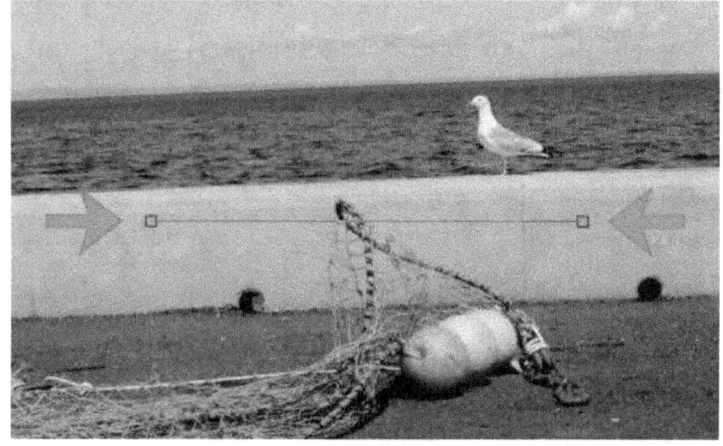

Move the handles along a line that you know to be horizontal.

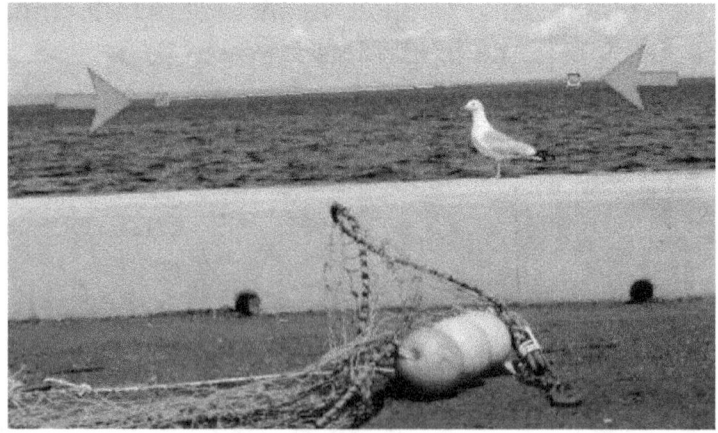

Once you accept the changes, here is the image, straightened as expected.

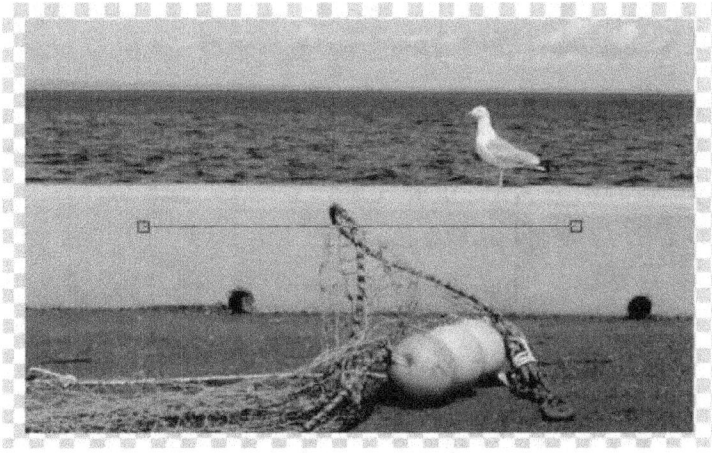

Although the default nodes for the **Straighten Tool** will be placed horizontally, you can also use it vertically. In fact, PaintShop Pro will recognize that the line is more vertical than horizontal and will assume that you are adjusting a vertical edge.

Just put the two nodes along the edge that should be vertical (and is not). PaintShop Pro will know it and will straighten it vertically.

No need to rotate your image to use it.

Since JASC PSP8, you also have the option to automatically crop your image in the same step, saving you time to crop in a separate process.

Rotating an Element in a Different Way

You probably know how to rotate an image by using the **Rotate** command in the **Image** menu. That is a good and very convenient way to get a precise rotation (you can choose the exact angle you want). Another way to rotate is with the **Pick** tool (or the **Deform** tool in PSP8-9). This might not be as precise as the previous process but it can let you view, somehow, the angle you are aiming for and what you are achieving. Here is what you get when you rotate using the center handle in the middle.

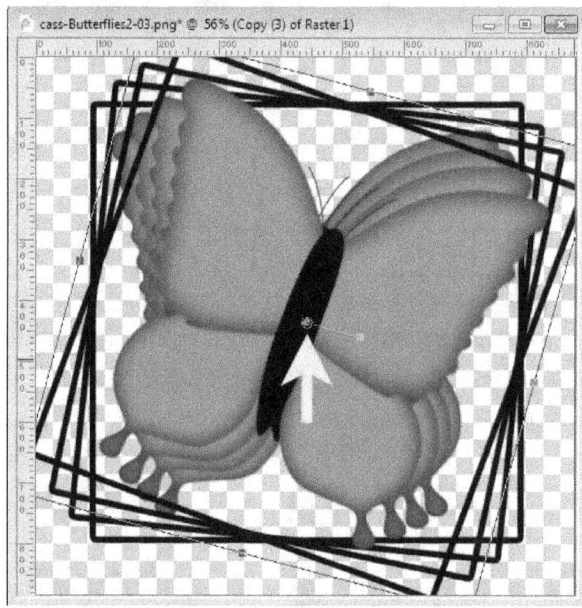

Although those tools will normally rotate from a center point of your image or element, there is a way to actually change the pivot point. It is right there, in PaintShop Pro. With the **Pick** tool active, hold the **Ctrl** key and grab that center pivot. You can then move it wherever you want!

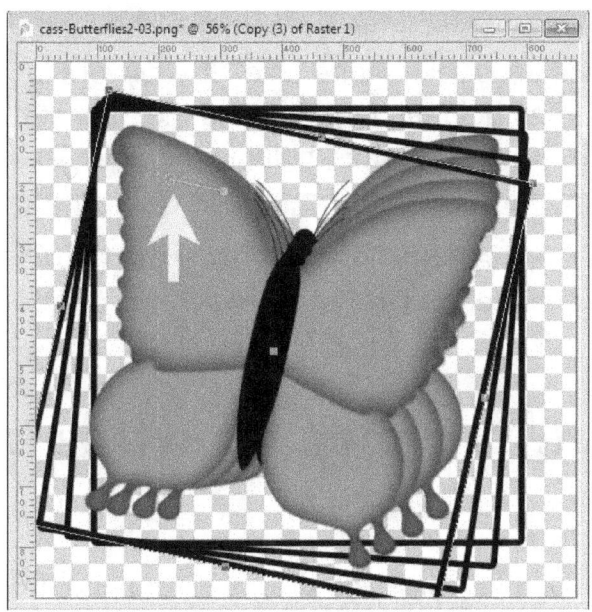

It is a great way to rotate several images or layers around the same point, not in the middle, as if they were attached by a single pin or hook.

Creating Pinking Shear Effect

If you use the square **Eraser** tip, try rotating it by 45 degrees and then, draw straight lines using the Shift key. Adjust the **Step** size and you can cut the edge of any paper, or photo as if you used pinking shears.

How to Move Elements with Precision

Moving an element is often done by looking at what we have. We know that this circle goes to the right, and we move it there. However, at times, it is essential to have an element moved by a very specific number of pixels and that can be hard using the cursor.

Making sure the correct layer is active, and the move tool is activated, use the arrow keys. One keystroke = one pixel. If you want to go faster, but still with precision, you can hold the **Ctrl** key and the element will move by 10 with one keystroke. But even better, holding the **SHIFT** key will move 50 pixels for each keystroke.

Note: In JASC PSP9, the **SHIFT** key will allow for 10 pixels move, and the **Ctrl** key does not change from the single pixel move.

Clicking and Dragging from One Image to Another

We are all familiar with the click and drag (or drag and drop) feature in word processing, and such, but did you know you can also do it in PaintShop Pro?

First, you have to make sure that the two images are visible on your workspace. That means that you have to have them untabbed. If you only see one image at the time, go to **Window > Tabbed Documents** and remove the checkmark there.

Now you should have two images: one with multiple layers, and one that should receive the elements from the first one. Activate the source image so you can see its layers in the **Layers palette**, click on the layer you want to copy, and drag/drop it onto your new canvas.

This is one shortcut you can use to save time when creating titles or wordart, if you have a layered alpha to start with (an alpha you ran through the Element Stacker[3] script). And if you want to see how it is done, check the video in the description. The run of the script is pretty boring because it does not "move" much, but then, you can see how I dragged and dropped the characters to write my name.

You can use the same technique to "copy" photos or other elements from one project to another one.

[3] https://creationcassel.com/stacker

Note: Starting with PSPX7, this process will change the focus to the target image so it will be slightly slower as you will have to reactivate the source image every time. But it is still faster than copying and pasting over and over again.

Note: this technique will do the same thing as copy and paste and every element dragged and dropped on the new project will land in the very center and not keep its previous location on the canvas.

A Quick Way to Close Images

When an image is open in the workspace and is no longer necessary, closing it will save space on your work area. Clicking on the X to close it will always trigger a warning window asking you if you want to save or not. There is a way to bypass this message: holding the **Shift** key when clicking on that X. That allows you to close several images, without having to stop every time to say you don't need to save. An even faster method, if you want to close ALL the images on your workspace, is by going to **Window > Close all,** and of course, if you hold the **Shift** key, you will close them ALL, with that ONE click.

Of course, if you want to save some of the images, this trick will NOT work for you. In such cases, save the ones you want, and then use this tip to close the rest.

Using a Rectangular Brush Tip

Although PaintShop Pro comes with a few basic brush tips, and you can add more with their Creative Content, there never seems to be a rectangular shape tip. By default, there are the round and the square bush tips. But it is easy to create a rectangular brush tip simply by changing the settings on the square one. By reducing the **Thickness** setting, the square will get thinner! You can create a whole variety of rectangles with different thicknesses.

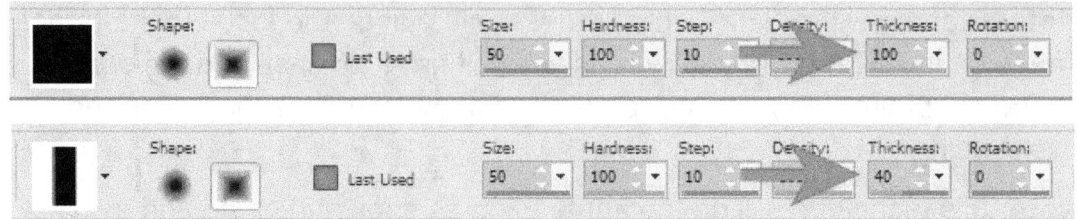

Using a rectangular brush tip, the thickness of your stroke will be different whether you are going horizontally, or vertically.

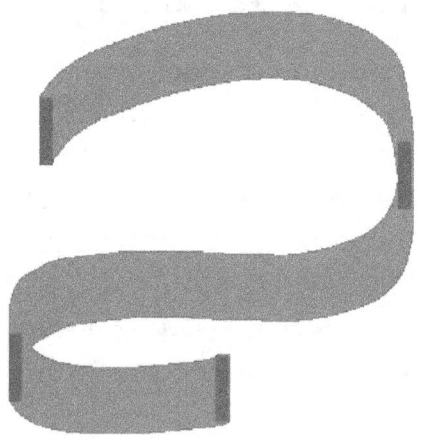

And if you change the angle slightly, you can get a great, custom calligraphy brush tip just like a calligraphy pen would do.

Creating Translucent Brush Work

Watercolor look can be pleasing but getting it with the default settings of the **Brush** tool is not simple. In fact, while watercolors would need to be translucent yet build up with each stroke, the default settings will keep everything too even. Adjusting the opacity does not always give a realistic watercolor look. However, there is one setting in the toolbar called "wet look paint".

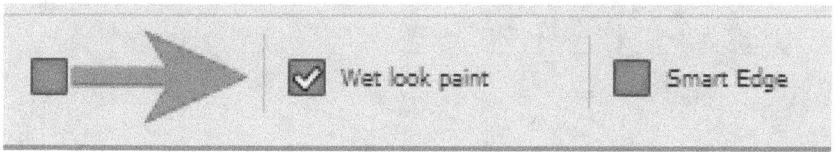

With the box checked, it will just "thin" the paint color so successive strokes will get darker, just like real wet paint. Make sure you "lift" your brush between strokes if you WANT the paint to get more opaque when you layer more strokes, but keep the brush going for a uniform transparency. "Lifting the brush" means that you won't click on the button of your mouse, or literally lift a stylus if you are using a tablet.

A Quick Way to Crop

If you want to save space, you probably like to trim your images to avoid excess empty space around any object or element. Whether you are a graphic designer or a scrapbooker, saving hard drive space might be a need. Trying to estimate where to crop your image might be tedious and ineffective, but there is a simple way to "trim" all the extra space around:

copy the layer, and paste as a new image (**Ctrl-C** and **Ctrl-Shift-V**). Everything extra will be gone without any measuring needed.

When you are cutting out an element from its background, particularly if you are using the **Eraser** tool to remove around the object, using the copy and paste as a new image might still seem to leave some unwanted space around it. If that is the case, it is not because PaintShop Pro is misbehaving, but instead, it is because there are some very faint stray pixels.

If that is the case, use the **Eraser** tool and erase along the edge where you didn't expect any gap. Then, repeat the steps.

Of course, this will only work with single layers, so if your project includes multiple layers, this trick won't work for your needs.

Cropping an Image with Multiple Layers

If you have multiple layers to an image, copying and pasting as a new image would only use one layer at the time, but if you activate the **Crop** tool, there is one setting in the toolbar called "**Merge opaque**".

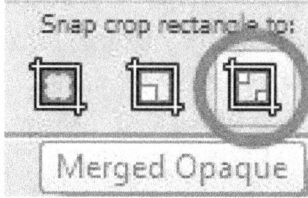

Click on that icon and the crop will take into consideration all the visible elements in all the visible layers.

Once you accept the cropping selection (by clicking on the green checkmark), you will have all the layers cropped, without any need to merge anything so you can continue to work on your layers separately.

Using the Guides

If you were to use a pen and paper, you could take a ruler to draw straight horizontal or vertical lines but since you cannot use a physical support when working with PaintShop Pro, there is a tool: the **Guides**.

The guides are actually "hidden" inside the rulers so you need to have those rulers visible. Go to **View > Rulers** and make sure it is checked. Now that you have those rulers, with your cursor, click inside the thickness of that ruler and drag your cursor onto the middle of the image to pull the guide.

Once you have the **Guides** in place, you will want to activate the snapping in order to help you align elements or draw perfectly horizontal or vertical lines. To activate that function go to **View > Snap to Guide** and make sure it is checked. Once enabled, whenever you will draw a line close to that

guide (whether using the **Pen** tool or the **Brush** tool), the line will stay perfectly straight. The same effect will happen when you make a selection, which will also "snap" to those guides.

Setting the Guides with Precision

Sometimes, guides need to be placed precisely, whether it is to measure the spacing between elements or otherwise. Placing the guides precisely just by pulling them at the right place is not always easy, even if you try to measure by the rulers. In fact, unless you are using a very small image or that you are zoomed in very close and the ruler is very large, it is hard to do on the first try. However, once you have placed your guideline close to the location you want it, notice that there is a little rectangle inside the ruler, at the end of the guide. Right-click on that rectangle and it will bring up a little window where you can enter the exact location (in pixels) where you want that guide to sit.

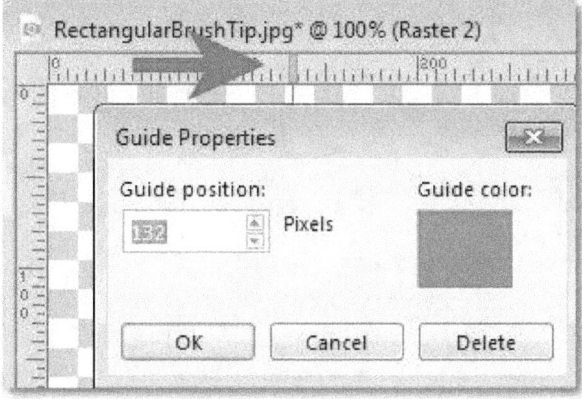

On this dialog window, you can also see the **Guide** color option. Click on it and it will open a color dialog window where you can choose a different color than the default blue. This might be a convenient way to use the guides if your project contains a lot of blues that would make it harder to use the blue guides.

Note: In some older versions of PaintShop Pro, if you are holding the

mouse button too long while trying to find the perfect alignment for your guideline, the program will freeze, so now, you can put it quickly and adjust it after.

Adjusting the Settings for the Guides

You know that you can change the color of the Guides, but you can change other settings too. If you are working on large images, maybe you find that you have to be too close to them to get your element or selection to snap to it and you would like them to grab your element even if it is more than the default 15 pixels it is set at. Then you can go **View > Change Grid, Guide & Snap Properties** and there, you can change **Snap Influence** value to match the size of your current project.

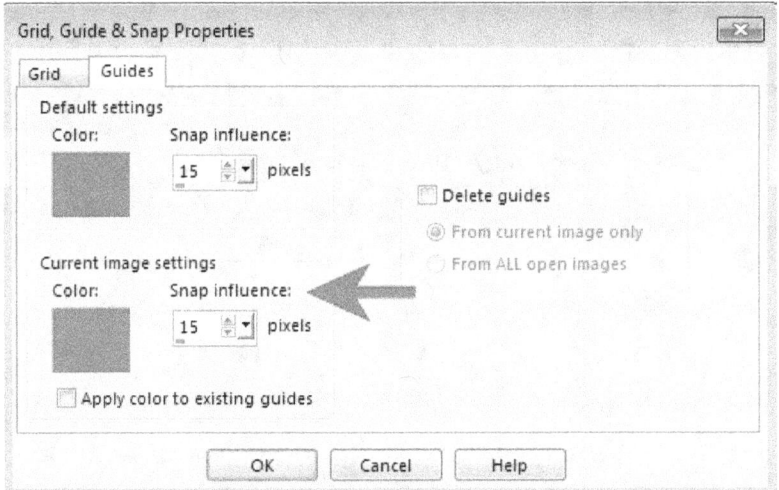

Removing the Guides

If you are working on a project that has a lot of guides, and at this point, you don't need them anymore, you can go to **View > Guides** and uncheck them. On the other hand, if you want remove some guidelines but not all, you can just grab the little rectangle in the **Ruler** and drag it out of the image. Another way would be to right-click on the little rectangle in the ruler at the end of the guide you want to remove and you will have the **Delete**

button on that window.

And if you want to remove all of them, you can get also check that option in **View > Change Grid, Guide & Snap Properties.** This might save time if you have a lot of guides to get rid of.

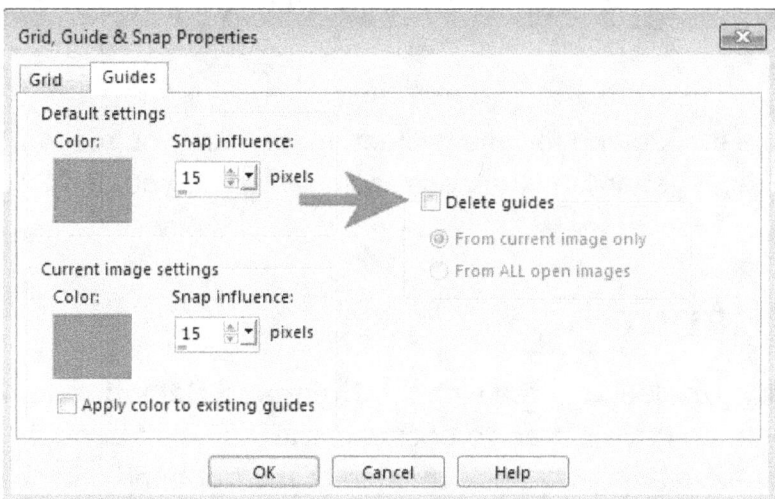

Picking the Correct Color

The **Dropper** tool has one purpose: picking a color from an image. However, occasionally, it looks like it is not doing a good job as it seems to pick a color that is different from the source. That is because the picture is typically composed of individual pixels of different colors or shades that will give a color that our eyes will interpret as different. So, if the **Dropper** tool is picking the color of individual pixels where you click, it can be different from what you expect and it is still doing a perfect job.

If you want to pick a color that is closer to what you SEE (or perceive) in any particular area, you can change the setting of the **Dropper** tool so it will pick the "average" of several pixels instead of a single one. Once you activate the **Dropper** tool, you can change the **Sample size** in the toolbar so you can pick a 3x3 or 5x5, up to 11x11 pixels area.

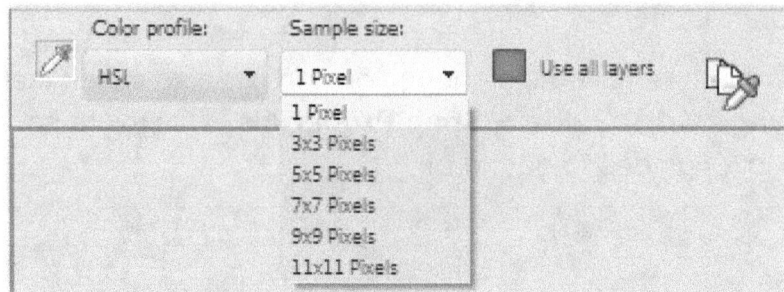

If you change that setting for one project, make sure you reset it back to 1x1 so you don't get an unexpected result, next time you use this tool.

Shaky Hand

When you try to select an area with the **Freehand Selection** tool, even if you don't need to have it precise because you just want a rough cut, do you find that you have a shaky hand? Instead of the freehand selection mode, set it to **Point-to-point.**

You can still get a rough selection that way while feeling more precise as you only have to click in a certain area instead of having a mouse that will move where you don't want. In addition, you can "take a break" between clicks without losing where you were.

Crop to the Right Size (1)

You know that if you want to crop a photo to a specific size, you can use the presets in the **Crop** tool. There are several preset sizes, like 4x6, 5x7 and so on. And you can move that area to fit your photo.

In older versions of PaintShop Pro, the presets will use the size it can, but if your photo is larger, you will see a small area that will be highlighted as suggested.

Don't worry. Simply move the nodes around that area, and it will keep its proportions.

If you are using an even older version of PaintShop Pro and you don't have that floating toolbar for the **Crop** tool, the presets are still available in the **Tools Options** palette like for any other tool.

Starting with version X5, whenever you choose a preset, it will automatically use the largest area possible for your given photo, even if it is actually larger than the size so you will have to resize the image to match the exact dimensions you wanted in the first place.

Figuring a Precise Rotation Angle

The **Pick** tool is often used to rotate elements as it is easier to see how far the rotation goes than using the **Rotate** command, which has to be set "blindly". However, the **Pick** tool does not seem to be very accurate, especially if one has to replicate the rotation on another element, with precision.

One little setting that might easily be overlooked is the **Angle**. Once you activate the **Pick** tool and you rotate the element on your image, the **Angle** value will change according to the rotation you applied. This allows you to SEE that you just rotated by 19.5 degrees, or 174.25 degrees, and when

you need to rotate the next element exactly the same way, THEN you can replicate the exact rotation angle.

And if needed, you can always reuse this value using the **Rotate** command if you need to use that tool.

Note: in the toolbar settings of the **Pick** tool, the angle always refers to the clockwise rotation, even if you rotate the handle counterclockwise.

Crop to the Right Size (2)

What would happen if you want to crop a photo to a particular format, but your starting photo is smaller than the preset you want to use? Of course, you cannot enlarge your photo with the **Crop** tool, but did you know that it will create a cropping area that is the correct proportion based on the size available? So if you wanted a small image with a 4:3 ratio, find the 4x3 (or 8x6) preset and it will automatically adjust to what you have.

After that, you might want to use a program that will allow enlarging your image with minimal distortion, like **PhotoZoom**[4]. It is not perfect, but can help if you are really stuck with a small picture that is meaningful to you.

Repeat Multiple Commands

If you want to repeat a command on several layers, you can always use **Ctrl-Y** (which means **Repeat**), but it will only repeat the very last command. What if you added a texture, a bevel and then a drop shadow, and wanted to repeat all those 3 steps on another layer? Here is the easy way: open the **History Palette (F3).** This palette contains all the steps you took while working on this particular image (each image has its own history). Select

[4] https://www.benvista.com/photozoompro

the layer you want to apply the multiple steps to. In the **History Palette**, select all the steps you want to repeat while holding the **Ctrl** key, right-click and select "**Apply to current document**". You will see all the steps being executed in order, with the exact same settings. Voilà! Perfect if you need to apply a series of effects to individual elements on a project (like individual letters, photos, ribbons, etc.).

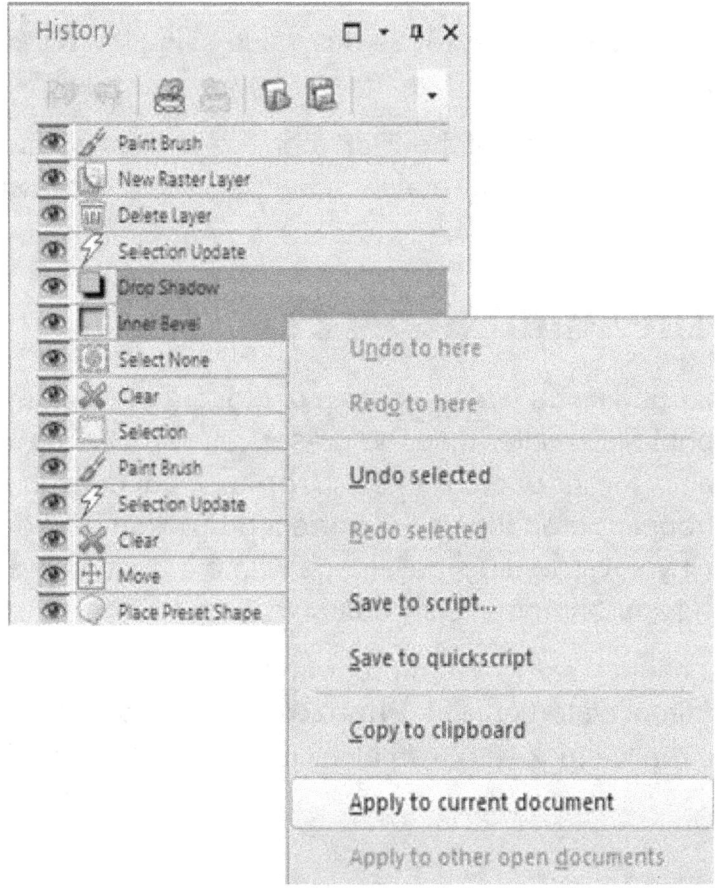

Note: if you have several images open, you can also apply these commands to ALL the other open documents. Just beware that they will ALL get those changes applied.

Crop, Portrait or Landscape

In recent versions of PaintShop Pro (since PSPX5), the **Crop** tool has seen

an additional feature: the ability to switch the crop area from portrait to landscape, while staying centered on the same point. This means that if you are hesitating between a vertical crop and a horizontal one, keep clicking that **Rotate Crop Rectangle** and alternate from one another before making your choice.

All Crooked

Do you sometimes take a photo of a layout or a photo either because you cannot scan it, or because you are in a hurry? If so, it is very possible that the picture is not perfectly square. What do you do? Use the **Pick** tool to straighten it? Maybe but there is a much easier method: the **Perspective Correction** tool. You'll find it with the **Straighten** tool (or the **Raster Deform** tool for older versions).

Once the tool is activated, place the corner nodes on the corners of the page or photo you have (of course, you have to have corners to identify those angles, otherwise you have to guess).

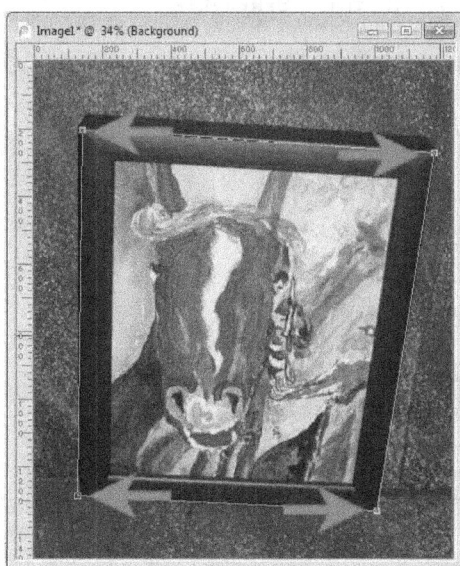

Then apply and, the whole image will be straight, as if you took it perfectly facing the camera. See how much better it looks now.

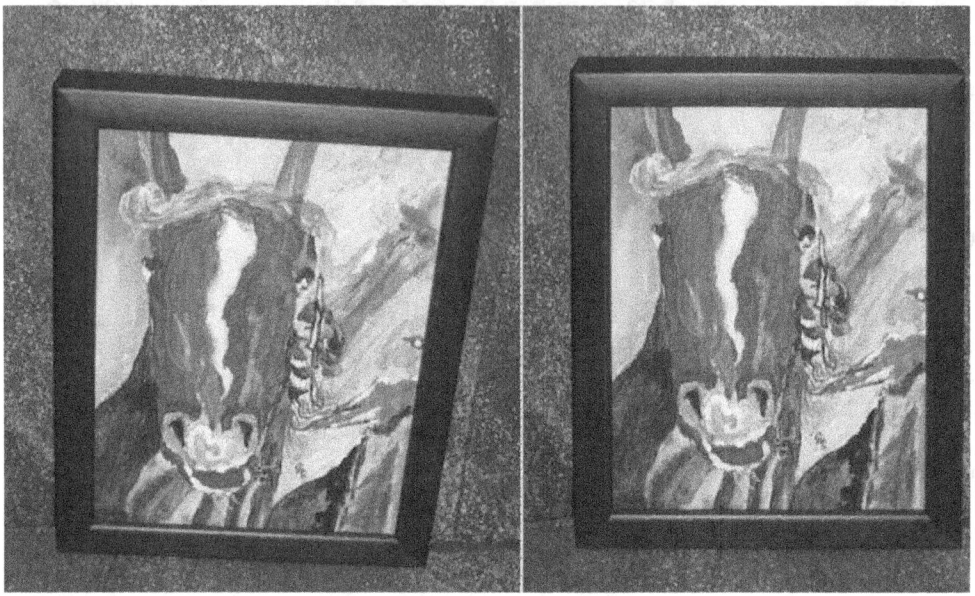

Where Is the Middle?

To place an element in the center of an image, you can just copy and paste it in the image as it will automatically be placed right in the center, but what if you want to know WHERE the center is?

With the brush tool, on a separate layer, stamp a 2 or 3 pixels "dot" (if you have an even number of pixels for the whole image, pick 2px, if you have an odd number, pick 3px). Cut it (**Ctrl-x**), paste it as a new layer (**Ctrl-v** or **Ctrl-L** depending on your version).

And voilà, the dot is right in the center.

Rotated Crop

By default, the **Crop** tool will offer you a straight area to select; something with vertical and horizontal edges. However, since many people seem to like angled photos (look at all those angled selfies), you might want to do

the same with any straight photo.

Once you have the crop area defined, when you hover the mouse over the corner handle, it will turn to a double arrow, allowing you to resize the area, but if you move the mouse a tiny bit AWAY from the handle, it will become a curved double arrow, allowing you to rotate the selection yet using the same size.

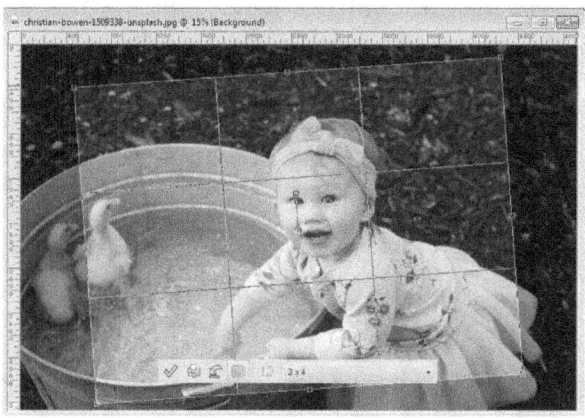

This means that if you wanted to crop to a 4x4 inches area, the rotated area will also stay at that size, so your photo will be the exact size you wanted. No tweaking needed!

Note: Starting with PSP2018, the **Crop** tool will actually rotate the image instead of the crop grid. This is meant to let you see what the cropped photo will look like, without having to lean sideways.

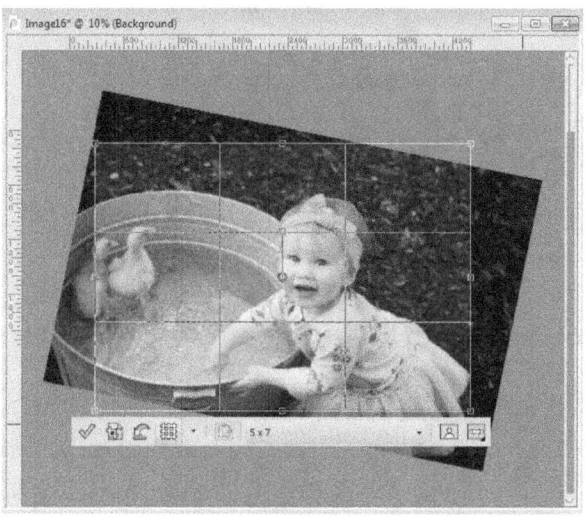

Flood Fill an Area Without a Selection

If you are like me, sometimes, I will want to flood fill a particular "hole" in an image, or around the image. If I use the **Flood Fill** tool, and just click where I want the color to go... surprise... the whole layer gets colored.

Did that ever happen to you? Then you think "Oops... I forgot to select that area". Yes, you can do that, select the area with the magic wand, THEN flood fill, but guess what? You can save yourself that step.

You CAN flood fill that area without having to select it first. How? When your **Flood Fill** tool is activated, check out the **Tool Options** palette (**F4** if you don't have it up) and see how you can choose a match mode. Just like the options you have for the magic wand, you can use them for the flood fill.

Choose opacity and flood fill the outside of the element. You want to replace all the yellow by pink? Select the **Color** as a match mode and click the yellow with the flood fill tool. Play with the tolerance for more accurate "coverage", just like you would do with the **Magic Wand**. Isn't that neat to know?

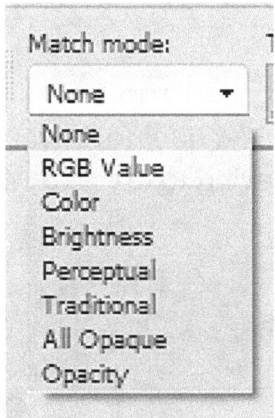

Un-erase

Do you sometimes, happen to work with the **Eraser** tool, maybe to clean up an element for example, and only after quite a while, you realize that this little spot that you deleted was, in fact, supposed to stay there. Duh! You

can use **Ctrl-Z** but that is not the last part you did. In fact, you did it quite a while ago and you don't really want to undo everything you did so far. Right? Well, believe it or not, you can UN-erase that spot. How? Simply "erase" the spot while right-clicking. Isn't that amazing all those hidden gems in PaintShop Pro? Beware that you cannot UN-erase an area that was not erased (or was already empty); in that case, it will turn to black.

Note: the UN-erase function will only work with 100% opaque areas in most PaintShop Pro versions. But starting with PSP2018, the opacity will be maintained.

Filling Multiple Sections at Once

Sometimes, you might have several areas selected (maybe a few but maybe dozens) and you don't want to have to click on every little area that is selected.

The easiest way to get them all filled with the flood fill tool is to select the **Match Mode** to **None**.

Then, you only have to click on ONE area and they ALL are filled. Saves time!

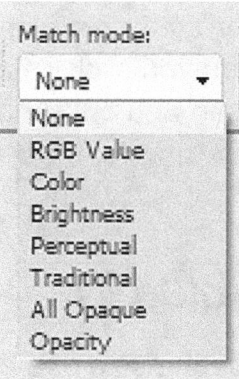

Cloning Anyone?

Did you ever use the cloning tool? It is great if you want to remove a little

section and replace it by a something else. I have used that once, to remove the electric wires coming on a house, as I was able to clone the siding over top of the wires so you had a nicer look (honestly, the wires were not that good looking!). Although you might have used the cloning tool to clone from one section of the image to another one, did you know that you could clone from one IMAGE to another??

To clone, just left-click the source (where you want PaintShop Pro to copy the pixels from) and then right-click where you want those pixels pasted. You will see an X to indicate where the source is, wherever you choose to paste it. That allows you to see if you will be cloning a good area, or not and you can then change the source.

Of course, you need to have your images in an UNtabbed mode so you can see both images side by side. If you don't see them, go to **Window > Tabbed Documents** and uncheck it (it is checked by default, so you will have to uncheck it at one point or another).

Changing Brush Size (1)

How do you change the brush size? Did you know there is more than one way to do that? While you have the size setting active, try using the mouse wheel. It is quick, easy and won't interfere with your workflow. Click on the size value and scroll. Make sure you click on the size value though, otherwise, you will be zooming in and out! And this trick is valid for any setting like the opacity, the step, and for most tools too.

Changing Brush Size (2)

There is another way to change the size of a brush tip. This might not be as quick or intuitive but depending on your personal workflow, you might still like to know about it. Hold the **ALT** key and, while the brush outline is on your image, move the mouse upward to reduce the size and downward to increase the size! It might sound illogical but just imagine you grabbed a "handle" at the bottom, and it will be more "logical".

Rotate One or All Layers

You can rotate all the layers or only one layer at the time. The trick: check/uncheck the "rotate all layers" if you are using the **Image > Rotate > Free rotate** tool. But if you want to rotate only one layer, you can also use the **Pick** tool (or the **Deform** tool for older versions) and grab the handle to rotate to your liking. This last way is less "precise" but you can see a bit more as you rotate. These are two ways to achieve the same thing depending on what you want.

Unwarp

You have probably used the **Warp Brush** at one point or another. If you are warping a large area and want to undo PARTS of what you did, how can you achieve that? Using **Ctrl-Z** might mean you will have to redo everything. But what if it is only a section and NOT the last one you did? In the **Warp Brush** toolbar, did you notice the little iron icon?

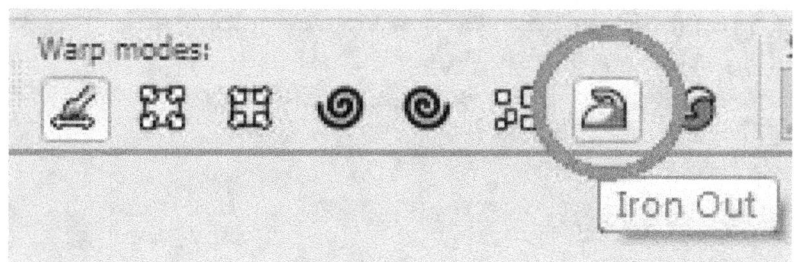

Well, if you use it, it will iron out where you had warped, no matter where it was on your project, so you can be more precise if you want to remove the warp effect (too bad it cannot be that fast when ironing a shirt!)

What Is the Angle?

How can you find out the exact angle of an element on your project? Use the **Straighten** tool! Not what you would expect, right? But try it. Activate the **Straighten** tool, and place the nodes along the edge you want to "calculate" the angle for. Then, before applying, check in the tools toolbar and one setting is the **Angle**.

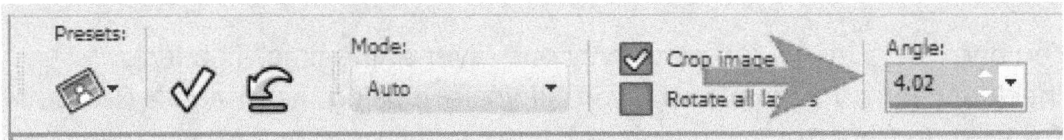

It will change as you angle the line so you can take note of the exact angle now. Perfect if you want to replicate something and you don't want to guess!

Emboss

You can emboss using the **Effects > Texture Effects > Emboss** command, but this will apply the embossing to the whole image. What if you want to only add that effect to a part of the image?

Look for the **Emboss** tool in your tools toolbar. With it, you can apply the effect using a brush tip and only where you want instead of the whole image. Did you ever use it in that way?

Aligning

Since version X4, you can select multiple layers at the same time. This led to the addition of an option to align objects that are not vectors. In the past, you could only use that command with **Vector** objects, but were left having to manually align the **Raster** layers, possibly using the **Guides**.

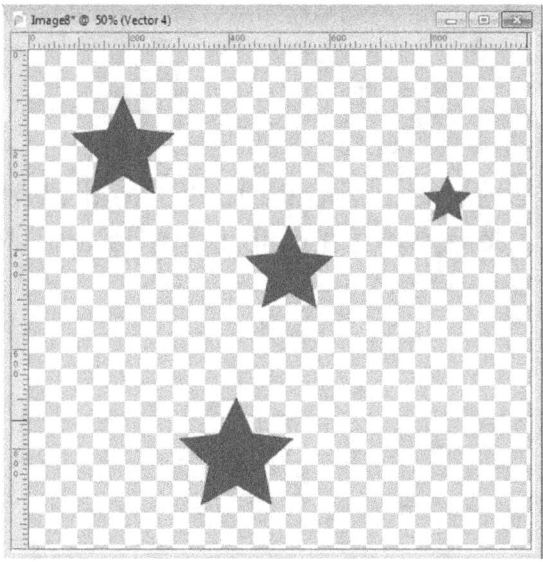

In order to align objects, simply select all the layers in the **Layers** palette, holding the **Ctrl** key.

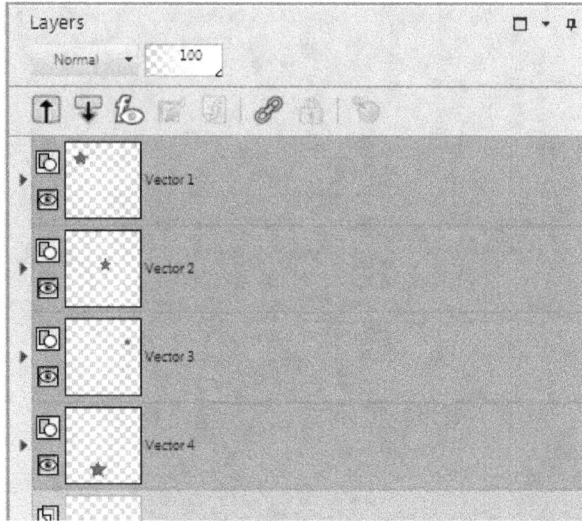

Then go to **Objects > Align** and there you will have a lot of options to align elements to the top, bottom, vertically, horizontally, and more.

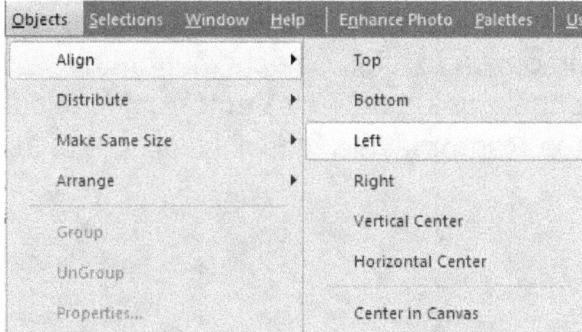

And here is what the image would look like if all the stars were aligned left (as if there were a guide on the left side of the one that is the most to the left):

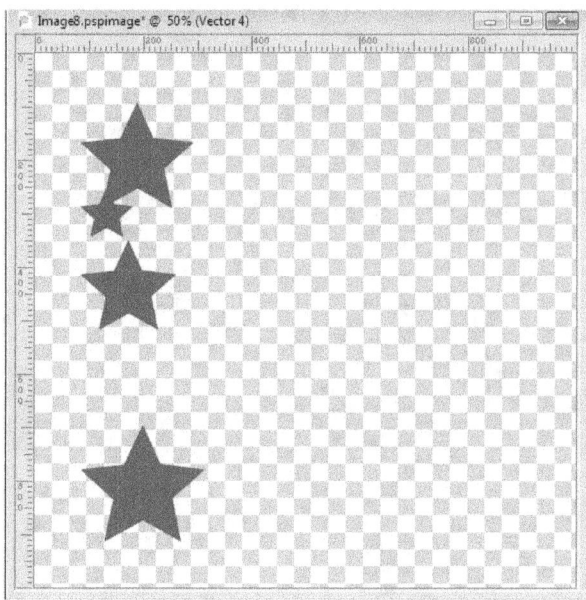

If you are still using an older version of the program and cannot access this functionality, there is a script for it, called **Align Raster**[5]

What Is a Step?

Various tools have a "**step**" as a setting, but it is not measured the same way with every tool. For the **Picture tubes**, for example, the steps are measured in pixels, so a step of 10 means that the tubes will be placed every 10 pixels. However, the tools like the **Brush** and the **Eraser**, the step is actually a percentage of the size of the tip. For example, a brush tip of 40 pixels, combined with a **Step** of 100, means that there will be a brush impression every 40 pixels (40 x 100%) but if it is set to 150, they will be placed every 60 pixels (40 x 150%). Did you know that?

[5] https://creationcassel.com/align

Text and Fonts

A lot of projects you will create in PaintShop Pro will involve the Text tool or various shapes. Those two can be created with such a wide variety of settings that there is a lot to discover about how they work and how you can save some time and work more effectively.

Text on Texture

Adding text or designs on a textured surface can be tricky. Using a fully opaque color will make it look quite fake as there is no texture showing. If one wants to show the texture below, it might be tempting to simply lower the opacity of the text or design layer. It could work for some colors and some textures but typically, it will just make the color lighter then intended. There is another method that would often be better: the Blend mode. Try using **Overlay**, **Screen** or **Multiply** to do the trick: you will still see the text or design clearly, yet the texture underneath still shows beautifully. The choice of the blend mode will depend on the colors of the text (or doodle) and the colors below. Try it next time you want to write or draw on a textured surface!

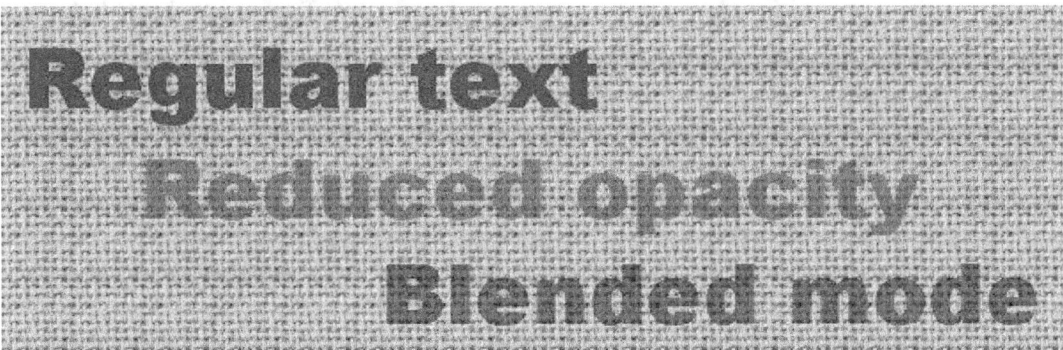

Multicolored Text

Do you know you can change the color of individual letters in a word or word in a sentence with the text tool? Did you want to type some text and emphasize only one word? Did you think you needed to make them separately? In fact, it is easy: simply select the individual letter, word or group of words and you can then apply the style you want. This way, you can change the color, the font or even the size of various strings within your text.

Change COLORS
just for fun

If you are using an older version of PaintShop Pro that uses the **Text Entry** window, it is just as easy since you can select the letters, words or group of words in the window and apply any color, size, font or style change.

Using New Fonts

Many people are "font junkies". Whether you are, or whether you just want to use some special fonts here and there, you do NOT need to install ANY font on your Windows. In fact, you don't even need to install them on your computer either!

You can use a program called TheFontThing[6] (you need to download the second file, the one without the installer) and whatever font is visible in the display window of TFT will be accessible in your PaintShop Pro.

[6] https://creationcassel.com/tft

You can learn more about using this tool in this article about **TheFontThing**[7]

Saving Your Text

I am sure it has happened to you before, that you added some text in a layout, converted it to a raster layer, added various effects (bevels, shadows, etc.) and post it or share it, only to realize, later on, that there was a typo, or a date error or that you simply wanted to change something.

But how can you do it since those vector layers have already been converted to raster in order to apply all those effects? Unfortunately, you might not be able to do much after the fact, but you can prevent this annoying situation in the future. It will require two steps: first of all, duplicate the vector layers, hiding the originals before converting the other one to raster to add all the effects.

The second step would be to include the various settings in the **Image Information** so you can find them later.

[7] https://creationcassel.com/tft

This is where you can include any particular information that you want about the text, the image, the supplies used, etc.

Of course that might be optional since you might want to redo all the effects anyways.

Simple? It can surely save you a few headaches!!

What Font Was It?

Did you ever happen to use a specific font in a project and then, a few months later you want to know what font it was but cannot remember? Maybe someone just asked you because they LOVE that font. Maybe you want to make an alpha with it. Or maybe you need to make a correction to a date, a typo or other. If you always keep one vector layer un-rasterised and

hidden, it will be easy for you to retrieve it. Double-click on the vector layer and see what font is associated with that text.

If the font is not among your "default" installed fonts, when you open the project (in layered format, of course), you will see a little window stating that font X is missing, and asking if you want to replace it. No need to replace it. Just take note of what font is missing, search for it on your computer and view it with **TheFontThing** and it will become available. Then, open the same file and that popup should not appear. This is what you get if you try to open the layered image and one font is not in your default or available fonts.

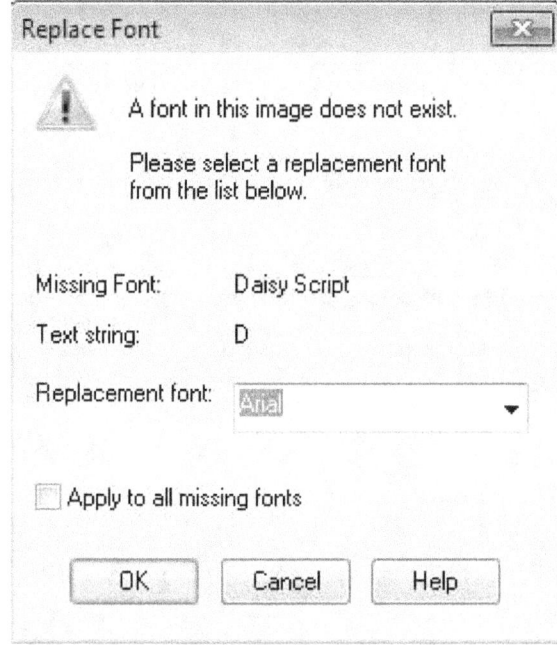

Of course, if you had used more than one font on your project, you will get a popup for the other font. If that is the case, it is up to you to determine which font you actually need to access to complete the edit you needed in the first place.

If you only wanted to find out what font it was, then, take note of the font it says is missing, and if it is not the one you were looking for because you had more than one, just allow PaintShop Pro to replace the font by Arial

(the default) and it will give you another popup for the next missing font. Once you have "replaced" them all, and noted which fonts were missing, you can just close your project without saving it.

Text Tool in X3 and Up

Are you used to the old way to enter text with the **Text Entry** window available in older versions? Starting with PSPX3, the text will be applied directly onto your project instead of that little window. For most users, it is a great change as you can edit directly ON the project. But if you have become accustomed to the use of the **Text Entry** box and you are missing it, you can still get it; when you click on the image to "activate" the **Text Tool**, simply hold the **SHIFT** key, and you will get your **Text Entry** box and you will be back in familiar territory!

And if you want to use the **Text Entry** box while editing a text that is already on your project, you can double-click the **Text** object in the **Layers** palette, while holding the **SHIFT** key and instead of simply activating the text on the project, it would bring up the **Text Entry** box with your text that you can edit.

Vertical Text

Almost all the text and titles on projects will be horizontal, from left to right, the way we normally write. However, sometimes, you might want to have the text vertically placed. How would you do that? One letter at the time and align them with the guideline? That is one way to do it but it is pretty long. Did you ever notice the setting for **Direction** (or **Text Flow**)? It will allow you to have all those letters perfectly aligned, in just a few seconds. Give it a try next time you want to have a vertical title!

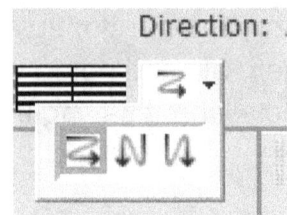

Text on Path

You probably know that you can click on a path with the cursor of the **Text tool** and the text will follow the path but do you know that you can write your text away from the path and once you have it typed, you can put it on the path? Yes you can. Holding the **SHIFT** key, click on the path object and the text object, then go **Objects > Fit text to Path**.

But that is not all. You can also remove the text from the path with **Objects > Detach Object from Path**. This will also allow you to create a different path, and put the same text on it without having to retype it.

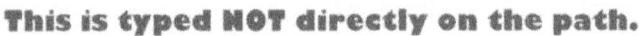

Paper Filled Text

In scrapbooking, whether you tend to use alphas or fonts to create text, what is the fastest way to have text filled with the paper of your choice?

64

Using the paper as a background material and type it in? That might work to a certain point however doing it this way does not allow you the option of selecting a specific area of the paper to display the pattern as you wish. So what can you do? Open your paper, and type in your text directly on it but creating it as a **Selection** (instead of the traditional **Vector** format), then, using the **Move** tool and the right-click, move the selection wherever you want on the paper to highlight any particular section of the paper (or avoiding some). Then, copy and paste on your current work. It is that simple.

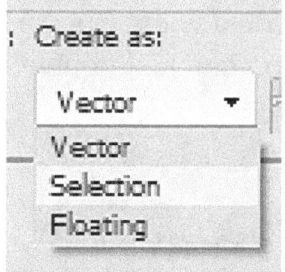

Accept This Text

I loved the way the text was added in earlier versions of PaintShop Pro: with the text entry box. I guess I learned to use it and I liked it. Starting with version X3, PaintShop Pro will allow you to have the text added directly on the project. That is good and a lot of users prefer that. However, I hated to have to go all the way up in the toolbar to "accept" the text by clicking on the checkmark.

I would always forget, and I felt it was a long way to click that little checkmark for everything I would write. But you don't HAVE to go click on that little checkmark? Yes, you can just double click somewhere else on your canvas and you are done!

See the Font in Action

Starting with PaintShop Pro X4, the **Text tool** has an added feature: you can view the result of a font change without changing it. When you have your text selected, either on your project or in the **Text entry** window (if you still prefer that way to enter your text), just pull the list of fonts, and hover your cursor over the various fonts you have on your list and the text on the project will change, temporarily, to the font that is highlighted. That allows you to really see what the text will look like, in shape, and size instead of having to select the fonts, one by one to test and decide which one you like better for your current project.

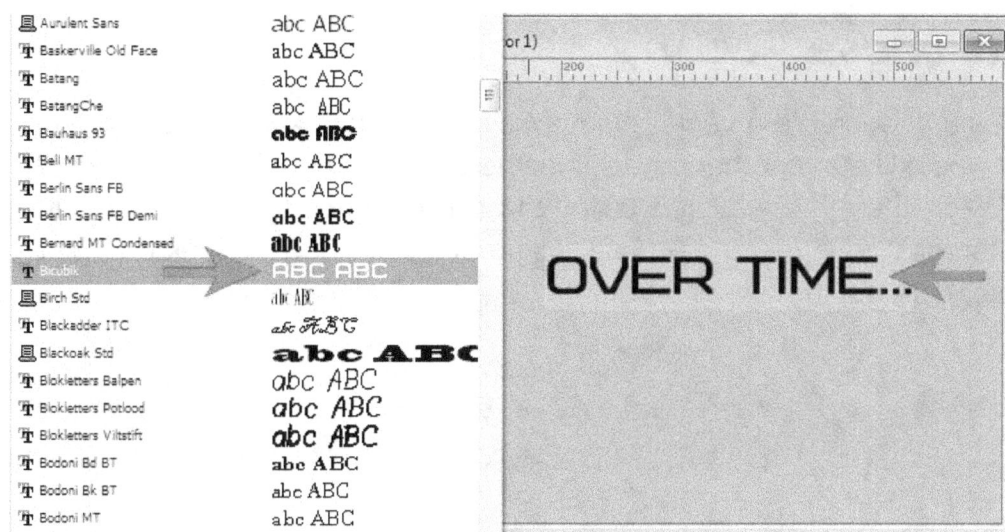

From Font to Shape

Do you have a few dingbat fonts that you like to use but are annoyed at having to find which character gives which design? Do you have some favorite designs you like to use but hate having to search for them? You can convert a dingbat font into preset shapes, so you can simply pick the shape you want from the drop down list and use it directly. Wouldn't that be easier? Use Suz Shook's script to do that. You can grab that script here[8]. Have fun.

[8] https://creationcassel.com/Suz

Cut Those Vectors

Did you ever create a vector element, worked a lot on it only to find out that you would like to cut that path somewhere and you don't want to redo it all? Well, there is a way: it is called the **Knife** mode. Just like a knife, it will cut through your vector path and will create new nodes. It looks like one of these, depending on your version.

Once you cut through a path, you will see a larger node. In fact, it is two nodes.

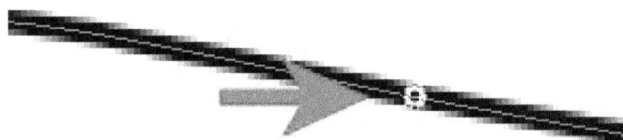

You can manipulate these nodes, separate them, move them, etc.

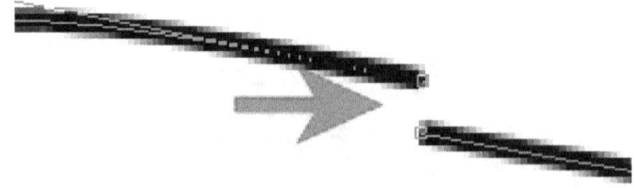

And if you cut in two places, you can even remove the path between those two locations.

Resizing Wrapped Text

When using text wrapped inside a selection, that selection will "stay" where it is, even if you resize your layered image. This means that the text will end up outside the image if you resize the vector version of it. If you need to resize a project that includes wrapped text for posting in a gallery, a forum or to include in an email, it is simpler to resize a merged version of it. That way, the text will be resized like the rest of the project.

Saving Wrapped Text

If you are working with a newer version of PSP and want to save a .pspimage file to share with a friend, they might have issues if they are working with an older version than you. If you know (or if you want to avoid any issue), you might need to save your .pspimage files with compatibility set to an older version (in the save as... dialog window, click on the **Options** button to see those versions you can make it compatible with). However, BEWARE that if you have that changed for an earlier version AND you are using the **Text Wrapping** feature of PSPX7 or more recent, **you WILL LOSE your text** when saving your file, even if YOU are reopening it with the same version on the same computer. So whenever you use that feature, make sure the compatibility option is set to X7 and newer. ALWAYS.

Note: PSP will let you save in any compatibility format but will not warn you about your wrapped text. This could mean quite a bad surprise.

Edit Rotated Text

Sometimes, a text that is rotated at 90 degrees is a good detail to add to a project. As long as it is left in vector format, you know you can still edit it,

right? It is just like text on a path, in a circle, or others. Whatever the shape or direction of the text, it can still be edited. So, have fun with your text.

The Same Text Style

If you ever need to put text in the same way, like on a photo caption, or a header, etc., you can save a preset for the text. It will save all the settings, like the font, the size, the colors, the line style, etc. Next time you will need those settings, type in your text, highlight it, and choose the preset. Voilà!

Shapes and Drawing

Various tools are available inside PaintShop Pro and although you might like to draw freehand, and you can, there are also other methods to work with shapes. Several tools are available to make your work easier, and the end result more refined.

Anti-alias

Anti-alias is an option available for the **Selection** tools. Honestly, I am not sure what the word itself means, but something sure, if you are selecting any curved shape, and the **Anti-alias** box is checked OFF, you will see very rough edges along the curve. That is because each pixel is either "on" or "off" with a particular solid color. However, if **Anti-alias** is checked ON, you will see some discrete "feathering" along those curves, giving a much nicer finish even if each pixel is square. You can see that individual pixels on the edges are not just either one color or the other. Many of them are a shade in-between the two colors of the edge giving a smoother look all over.

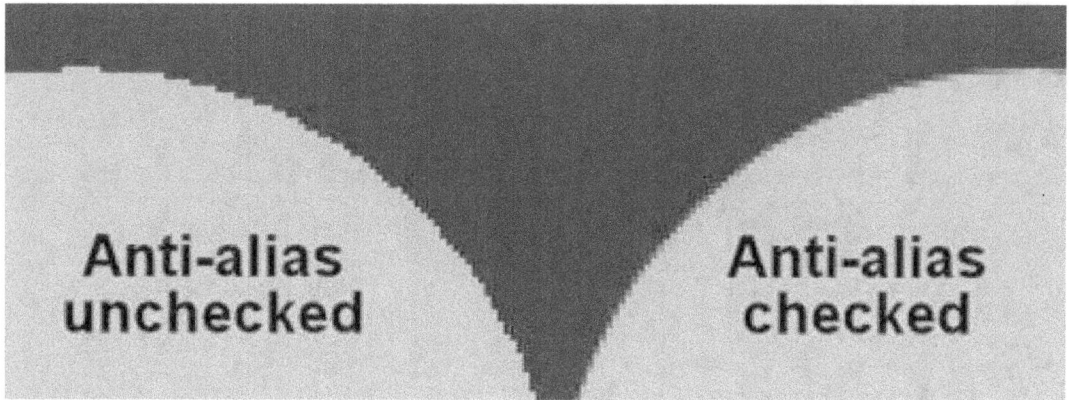

Try it with and without this feature checked. You will see the difference by yourself. It is definitely worth that extra click for better quality designs. And if, during a project, you find your edges start looking odd, just recheck that setting. You might have accidentally un-ticked the box.

Preset Shapes or Vector Shapes?

When you are using **Preset** shapes, they are, by default, created as vector. But you can also create those same preset shapes as rasters. Since you can apply various effects, textures and shadows to rasters but you can't with vectors, this might save you a little bit of time, especially if you know you won't be editing/resizing/rotating your shape (remember, rasters will not stay neat if you distort them though, and especially if you want to enlarge them).

In the tool setting, simply uncheck the "**Create as vector**" or "**Create On Vector**" and it will automatically create your shape as a raster. Beware that you will need to add a new Raster layer before you draw your shape since, unlike the vector shape, it will not create its own layer automatically. The location of that option is slightly different if you are using the **Preset Shape** or one of the other **Vector Shapes**.

For the Preset Shapes, it will be here.

For the other Vector Shapes, it will be here.

Lines for Every Style

Did you know that the **Line Styles** applied to all vector objects? That means you can use them with vector shapes, text and lines drawn with the **Pen** tool. Change the size for a fun effect. You might be surprised.

Drawing with the Brush or the Pen tool

When trying to draw, one might be tempted to only use the **Brush** tool as the **Pen** would produce a vector, which is not always what we want. But did you know that you can use the **Pen** tool without making it a vector. Just uncheck the "**Create as vector**" and you will have a much smoother line than with the **Brush** tool!

Spirograph

Do you remember playing with that toy when you were a kid? You can create some shapes that will remind you of those with a simple tool in PaintShop Pro: the **Symmetric Shape**. Set the **Mode** to a **Draw Stellated**, with LOTS of sides (over 100!), and check both **Round inner** and **Round outer**. Try it with no fill for best result, and have fun!

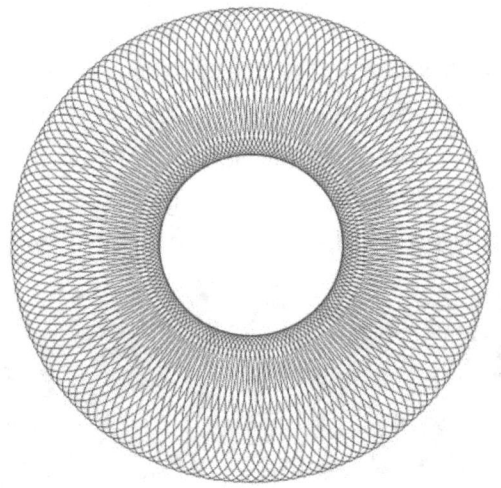

Regular Preset Shape

Do you, sometimes, want to use a preset shape but your result does not really look like the initial shape listed? Do you find that the heart is too thin or too wide? Or the rocking horse seems distorted? There is a simple way to prevent this: hold the **SHIFT** key when you drag to draw the shape and it

will keep the exact proportions it was intended to have.

Round Corners

If you have a photo and you want to round the corners a bit like the old kinds of photos, there is a very easy and quick way to do so. **Select All** (Ctrl-A), **Selections > Modify > Contract** and choose a value that will be depending on the size of your photo (let's say 50 pixels), **Selections > Modify > Expand** by the exact same amount, **Invert the selection** (Ctrl-Shift-i) and delete what is selected. The larger the value you contract/expand, the larger the radius of the corner will be. That's it!

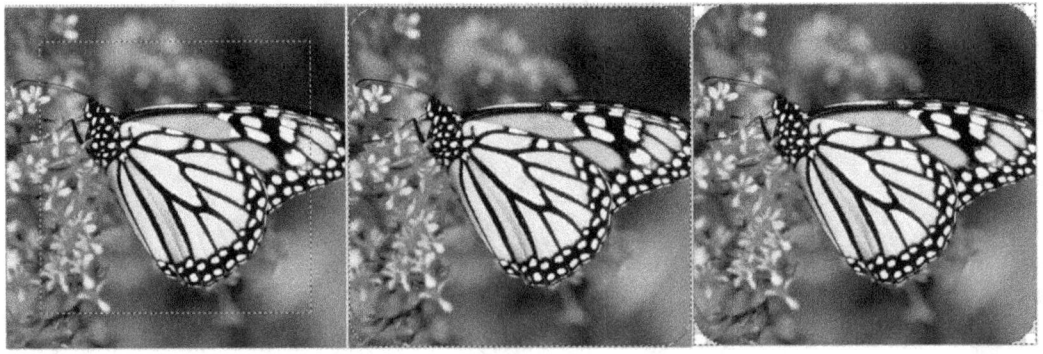

See the illustration of this tip in this article: Quick Rounded Corners in PSP[9]

[9] https://scrapbookcampus.com/Round

Adding and Removing Elements

Whatever you are working on, PaintShop Pro allows you to add and remove elements, layers and sections of them. There are some simple ways to make these addition or removal more precise and faster to accomplish.

Removing Extra Pixels

Another way to take care of loose pixels is by using the **Expand** command. First, using the **Magic Wand**, select the space outside your element. Then, to get a better view of the possible selections, go to **Selections > Invert selection (Ctrl-Shift-i)** and **Selections > Modify > Expand** by a couple of pixels. It will be a bit more obvious. Do you see some marching ants where they should not be? Select your Eraser tool with a 100% opacity and erase where they are. Repeat the process to double check that you got rid of any unwanted pixels.

5.5

Remove Specks and Holes

Sometimes, if you are trying to extract an element, you might need to clean up a few lost pixels. One easy way to help is to use **Remove Specks and Holes**. Just select all the space that *should* be empty with the Magic Wand, and go **Selections > Modify > Remove Specks and Holes**, and you will magically see those lost pixels "swallowed" by the selection, so you can now delete it all. Of course, that will not clean everything but it will help. Try it and you might find it more useful than you thought.

Watermarking

There are three main ways to add a watermark to your work to protect it.

You can go to **Image > Watermark > Visible Watermark** where you will get the option to choose any image and a variety of settings to add the watermark to your project.

You can use a free script from the store called... **Watermarking**[10]. This script will allow you also to add a design of your choice to a number of images in a single folder.

You can also use the new **Batch process** function added in PSPX8 that includes the option to add a watermark on a number of images of your choice, with various settings and options.

You have no more reason to leave your work open to being stolen and used. It is YOURS.

[10] https://creationcassel.com/watermark

Adding a Border

There are two ways to add a simple border around an image. The first and easiest one is with the **Image - Add Borders**. This allows you to add a border all around an image, and you can select to have all the borders even or not. You choose the color and the size. This is very convenient but you have to have your image as a background layer, so, you are limited to a rectangular border and everything flattened too, so you cannot do it on individual layers. It is hard to do if you have an element that is not rectangular. But there is another way to add a border. Although you have fewer settings to play with since you can choose only ONE width, you can apply this border around ANY element, ANY shape even if it is already placed on your layout (as long as it is not merged, obviously). Select your element with the tool of your choice and go to **Selections - Modify - Select Selection Borders**. You have the option to add border **Inside**, **Outside** or **Both sides** of the selection. Then, it is up to you to fill that selection with the material you want.

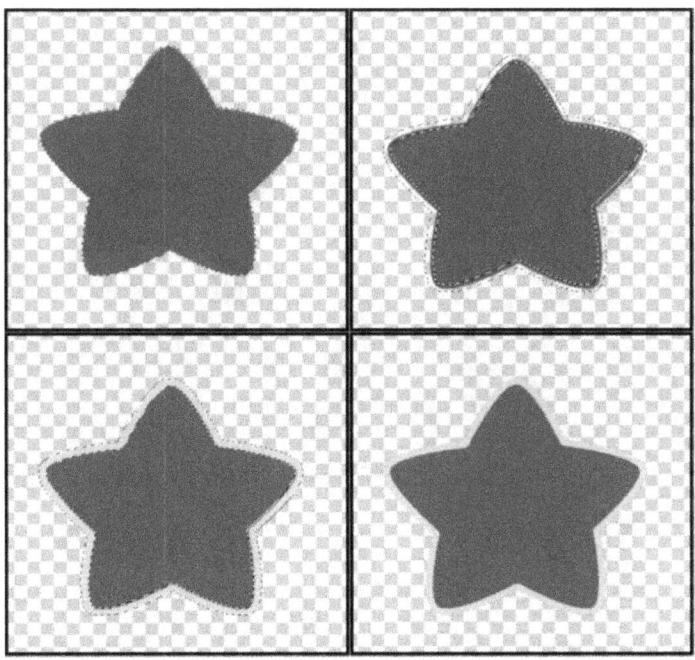

Drag and Drop

Do you know how to drag and drop from one layer of an image into another open image? Did you know that you can also drag one layer onto your workspace to create a new image with that layer only? This will save you time from copying and pasting as a new image.

Smooth Edges

You know that vector shapes will give a smoother edge than the **Selection** tool. However, you need a raster layer to apply various effects. How do you get such a smooth shape all the time? Create a vector, and use the **Selections > From vector object** and then, on a new layer, you can flood fill with the color you need. The edges will be as smooth as the ones for the vector itself.

Files

Whatever project you are working on, you will have to manage and manipulate files in different formats, with different names. There are ways to make your work with files more efficient.

Batch Rename

Downloading sets of graphics files that are not named properly for sorting can be annoying. Maybe you got an alphabet that has only the name of the kit but not the name of its designer? If this alpha has all the upper case, lower case and numbers, you might be there all night renaming them one by one. But there is a faster way. Check out **File > Batch > Rename**. From there, follow the prompts to choose how you want to rename the files, browse to choose the files to rename (yes, working in batch means you can run this on all your files in ONE operation). Then, sit down and enjoy. But you won't enjoy the peace and quiet very long because it will be done in no time! Talk about a time saver! Did you ever use that? Now, will you?

Changing File Format

Starting in PSPX8, you can use the **Batch process**, to change the file name of some of your files. Go to **File > Batch process**, choose the images (that will be opened), SKIP the action part (which would have been a script or other) and change the saving option with the new file format. That's it! The program will automatically open the file, do nothing, and save it in the new format.

Note: be careful in using this tip as you cannot just change a .png file into a .pspbrush or .psptube file. It would be best if you want to change a .png to a .jpg, or a .pspimage, to a flattened .jpg our .png. Also beware the .jpg format will lose any transparency from the file and it will be flattened, possibly with a white background.

Save Your Work

Why shouldn't you save your work only in jpg format when you need to pause your work to come back later? Two main reasons:
1- saving in a jpg format will flatten all the layers, so you can't edit much afterward
2- saving in .jpg format loses some quality every time you save, so if you save often, you are degrading your image every time. Not something you want to do, right?

Save Your Work in Progress

Do you sometimes work on a project and need to stop, either for the day or more, but you have several images opened at the time and don't really want to have to retrieve all those images, one by one the next time to get back to your project? There is a neat feature in PaintShop Pro that lets you save all the settings you have AND the opened images. Simply go **File > Workspace > Save**, choose the name of your project and make sure you check "**Include Open Images**" and the next day go back and reload it. Everything will be back the way you left it. Isn't that easy?

Save Your Progress

If you use the auto-save it is great, but it has an inconvenience too: it only writes on the same image, so if you wanted to go back to a version a longer time ago, you would have lost it as you only have the latest version. So if you are working a lot on your project, it is a good idea to save .pspimage versions with incremental numbers, so you can always revert to 2 or 3 or more versions earlier.

Using the Optimizer

When you save your work, you always save a copy in pspimage format and one in jpg format, right? How do you save your jpg? Do you go **File > Save as** and choose **jpg**? Guess what. You can save in file size by using the **JPG optimizer** instead of going straight to the **Save as**. Simply put, you then get the option to compress the image and reduce the file size. If you post layouts in galleries, sometimes they have file size limitations and unless you want to reduce the actual size of the layout, using compression is likely a more effective way to do so. You can find this option by clicking **File > Export > JPG Optimizer**.

Lucky for you, since PSPX8, you can actually adjust the file size and quality directly from the **Save As...** command.

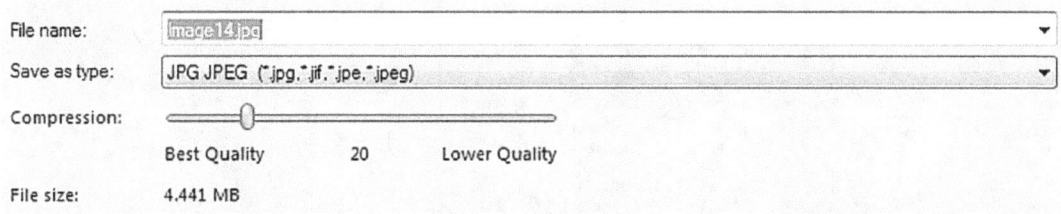

If you want to use the **Optimizer** for JPG and GIF and PNG too, you can get the **Web** toolbar up. You can check it under **View – Toolbars – Web**.

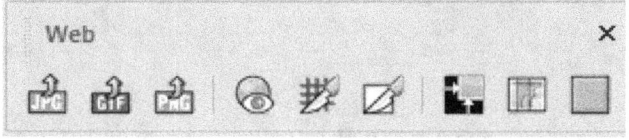

Sharing with Different Versions

Are you creating .pspimage files to share, give or sell to others? If the recipient uses an older version of PaintShop Pro they would not be able to

open your file, however, if you make one little change to YOUR PaintShop Pro, all the .pspimage files you will create will be useable by them. The next time you need to save a .pspimage file, use the **Save As** and in the dialog window, before you hit **Save**, look below that **Save** button and you will find an **Options**... button. Click on it, and you will see **Version Save as…** and a drop down list of various other versions you can save to be compatible with. If you choose PSP8 it will surely cover most versions still in use, including the recipient's. Once this is set for one file, it will stay set for future saves. So set it and forget it! (and everyone will be happy)

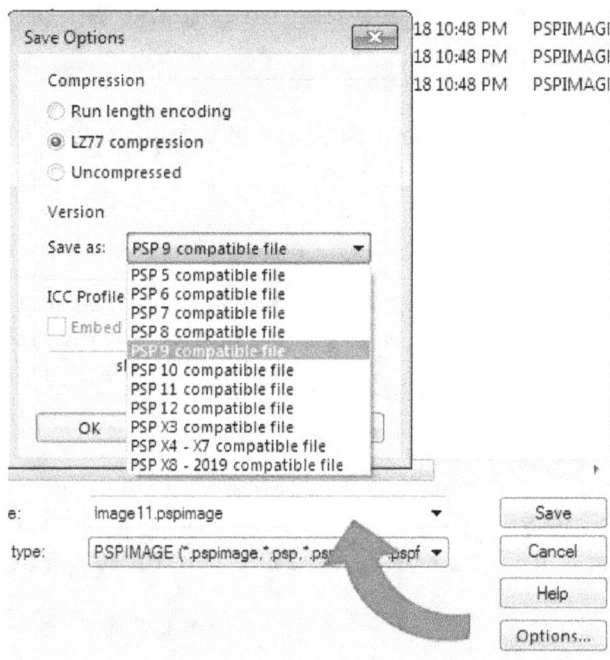

Note: Beware that if you are doing this with versions X8 and above AND you have taken advantage of the **Text Wrapping** feature, your text will be LOST, even if you are the one reopening the file in your current version. PaintShop Pro won't let you know so it could mean a bad surprise.

Save Image Information

Some PaintShop Pro users will work on their project and have to have a piece of paper beside them (or a Notepad file) to take note of all the elements and images used for credits? There is a way with PaintShop Pro to keep those notes and always have them available, even if it is next year! If you go in **Image > Image information**, you can then pick the tab "**Creator information**". There you can place your name (so nobody could claim this image as their own), but you also have a little blank window where you can type in all the elements you use, the font names, even some settings you would like to remember. And this information will stay WITH the image so you can retrieve it anytime later, refer to it, add to it, etc.

Workspace

The workspace is an integral part of your program. In PaintShop Pro, it can be customized to suit your particular workflow, so you are not stuck having to adjust your work habits to a set arrangement of tools and commands. This is one great feature of PaintShop Pro as you make it work for you, and not the other way around.

The Rulers

Did it ever happen that you worked on an element on its own, just to realize that once you put it against a full size project, it looks disproportionate? Maybe you need a ruler. I have seen many designers work without any way to see the size of their work. They know they have to open a 3600x3600 paper but that is about it. Do you work with the ruler visible? Yes? That is great. No? Hurry and go get them! Check in **View > Rulers** (or **Ctrl-Alt-R**). Easy enough.

Text NOT on Path and NOT Wrapped

You probably know how to add text along a vector path, but did it ever happen to you that you want to add text on top of a vector shape but NOT follow the path and then PaintShop Pro seems to insist on placing it on the edge of the vector shape? Do you want to win this battle? Simply hold the **ALT key** when you click to put your text. That will remove its "automatic" placement along the edge and will let you add the text "normally".

Starting with PSPX8, the **Text Wrapping** feature will take over. If you click inside a vector shape, it will automatically think you want to wrap the text inside. But just as mentioned above, if you hold the **ALT key** when you click

on the location to start your text, you will override PaintShop Pro's plan to wrap your text inside.

Dark or Light Workspace?

Until PSPX1, you had no option to pick a different color for your workspace, however, that changed in PSPX2. In PSP X2 and X3, the default workspace is dark and grey. Some people like that but some prefer a lighter background (personally I like a light screen better). You can change that from dark to light by going **View** and uncheck **Uses Graphite Workspace Theme**. That's it!

With PSP X4 and X5, you now have the option of FOUR environment schemes.

In version X6, the Medium Grey and Blue options were removed.

In version X7, the Medium Grey was added back and as of version 2020, the three grey options are still available.

Minimized Images

In PaintShop Pro, there are two ways to display the images: tabbed where you see only one image at the time, and untabbed, where you have many images on your workspace, a bit like on your desk. If you need to work with several images at once, maybe you want to have some "stored away" but not too far. In that case, you can just minimize the images and they will appear as little rectangles with the file name at the bottom of your workspace. Now, you can work with only what you need, yet, have everything handy.

Tabbed or Cascaded?

Do you prefer to work on various images and have them tabbed or cascaded on your workspace? Whether you prefer one or the other, you can always switch between those in addition to having images tile horizontally or vertically. Simply go in the **Window** menu and you will see all those options. What is the format you prefer? I tend to prefer to have all the images scattered on my workspace. I hope it does not mean I have a scattered mind.

Remember that some commands are easier to use with untabbed documents, like cloning between two images, dragging the Layers palette onto another image to name just a couple.

Save Your Workspace

If you ever happened to need reinstalling your PaintShop Pro, you know how tedious it is to reset your buttons, your palettes, and toolbars just the way you like them. You can save yourself some headaches by saving your workspace. Simply go **Files > Workspace > Save**. And when you are finished reinstalling your PaintShop Pro, just go **Files > Workspace > Load**.

Make sure you identify what version that **Workspace** belongs to. You should **NEVER** load a workspace from a different version, even if it would be more convenient than redoing your workspace from scratch when you upgrade. Although your PaintShop Pro won't give you any error message, any tool or functionality that was added to the current version of PaintShop Pro will NOT be included in your older workspace. You likely won't see any difference, or any issue in the beginning, but at one point or another, you might find that you don't have this tool or that option and likely won't remember that you had loaded the wrong workspace. It will then become a really tedious troubleshooting exercise that you could avoid right from the start.

To make sure you don't accidentally load a workspace from a different version, it might be useful to include the version number in the name of the workspace you saved.

Unwanted Guides? (1)

Sometimes, I want to draw with the **Brush** tool from the very edge of an image and I end up with a guideline instead of a brush stroke. Does it ever happen to you? Of course, you can turn off the **Guides** option but maybe you still want it on. So, how do you get to brush from the very edge WITHOUT getting a guide when you don't want any? Simple. Zoom out so

that your image is smaller than your workspace, and then grab the edge (in the corner if you want) and drag it wider than your image.

That way, you won't start your brush stroke in the ruler, but in the grey area around your actual image. Bye bye unwanted guideline!

Of course, if you are working with a tabbed window, this tip is not necessary since you don't have the rulers, right against the edge of your image.

Unwanted Guides (2)

Sometimes, you need to make a selection that starts very close to the edge, and while hoping to make your selection, you accidentally grab and pull a guideline. The tip about extending the edge of the image can also work for selections: start your selection in that "outside" area, and no guide will follow your cursor. Another little trick would be to start your selection either at the bottom, or on the right, away from the rulers.

Larger Icons

Do you have a hard time seeing all the icons on the PaintShop Pro workspace? If so, did you know you could use larger icons? Starting with PSP8, simply go **View > Customize** and under the **Options** tab, check the **Large Icon** box. If the small size is ok for you, no need to enlarge the icons though, but that is one option. And thinking of it, do you teach PSP to people with lower eyesight? It might be easier for them to see AND click on larger icons!

With PSP X4, the default is the larger icons, so if you click **Small Icons**, you still have that choice.

Starting with PSP2018, you even get three sizes for icons now. Although it is still available through the **Customize** window, you can also find it in the new **User Interface Menu**.

That is perfect to adjust to your own preference and monitor.

New Image Preset

Do you often use the same settings for new images? Same size? Same background? Same resolution? Save those settings as a preset so you can quickly get the exact same image next time. You want to create something with a standard 4x6 or 8.5x11 or other common size? No need to calculate the number of pixels you need for them; pull down the preset list on the **New Image** window and you should see a whole list of them! Take your pick!

Multiple Workspaces

You know that you can customize your workspace for your own workflow but if you are using your PaintShop Pro for very different tasks, you might find it hard to pick only the tools and commands you will need. You don't really have to do that because if you are using your PaintShop Pro for very different tasks, you can create a different workspace for each one. Say you do scrapbooking and you like to have some menus and palettes a certain way. Save the workspace with the name "scrapbooking". Then, if you also

tend to do a bunch of photo editing, maybe you will prefer a different set of menus and palettes. Create that workspace and save it as "photo". Then, next time you are going to work in scrapbooking, just reload the specific workspace you liked.

To save/load workspaces, simply go to **File > Workspace > Save** or **Load**.

Be sure you NEVER load a workspace from a different PaintShop Pro version. Although PaintShop Pro will let you do it, you might get odd results at one point later in time and you will have a hard time identifying the culprit (which would be your wrong workspace). To make sure this never happens by accident, include the version number in the name of the workspace you will save, like **X9-Scrapbooking** or **2018-Photo**.

Starting with PSP2018, Corel offers you, right from the start, two workspaces: **Essential** and **Complete**. This might be a little confusing for regular users since the **Essential** workspace is set by default, and if you are not aware of those different workspaces, you will wonder where your favorite tools are.

In PSP2020, there is also the **Photography** workspace that has been added, with a specific interface for photo editing and also an environment that allows you to use a touch device (which explains the large icons and a lot of "empty" space).

Add to Swatches (1)

When you work on a project and you want to keep the swatches for future use, there are several ways you can do it.

1- With versions X6 and before, in the **Materials Palette**, click the **SWATCHES** tab and then click on the **New swatch** icon at the bottom. Choose a name and pick the color from the **Material Properties** window.

2- In versions X7 and up, there is a different icon to add the swatches to your palette, but it works the same EXCEPT that you can save your swatches in different palettes instead of all in one big collection.

3- From the **Material Properties** window, once you choose a color (or gradient or pattern) click on "**Add to swatches**" on the bottom corner.

It's that simple!

Add to Swatches (2)

Did you know that in the swatches, you can also add gradients and patterns? This can be a time saver if you have tweaked a particular pattern or gradient. And you can save them with a texture too! They will end up just like presets! This is a quick and easy way to access and reuse them.

Note: if you created a gradient using the **Foreground-Background** gradient, the specific colors will NOT be saved; they will keep changing based on the current foreground and background colors you have.

Accented Characters in Scripts

Starting with version X2, PaintShop Pro stopped recognizing some characters in scripts. What would happen is that a script would work perfectly fine in older versions, but when the exact same script was run in X2 or newer version, nothing would happen. The script just would not start at all. Nothing is frozen, but nothing happens either. That is because accented or special characters were no longer understood by Python in version X2 and up. This meant that if the author's name or a commented section of the script (not related to the execution of the process itself) included an accented character, like "é", the whole script failed. This might not happen to scripts coded by English speaking coders but it might happen with those using foreign language and accented characters in their name or in comments. So if you have an older script and notice that it just won't run in a version of PaintShop Pro after X1, that might be the issue. You can either contact the author about it, or if you feel comfortable enough, you can edit the script yourself and replace those characters by something else, or remove them altogether. One thing for sure, they would NOT be part of the code itself so replacing it would not cause issues to the script.

Contact Sheet

Maybe you would like to get a visual list of all your photos from your last vacation or maybe a list of all the papers and elements in a particular scrap kit you have (or did). It is a great way to create a visual index of several files. Did you know that this function is part of PaintShop Pro? Starting with PaintShop Pro X3, you can find the **Print Contact Sheet** from the **Organizer palette** (Shift-F9), under **More** options. If you are still using an older version of PaintShop Pro, there is still a script in my store called Contact Sheet[11] that can do the same with a few additional features.

[11] https://creationcassel.com/contact/

Many Open Images to Save

If you have been working on editing many images and you end up with all of them still on your workspace, and you would like to save them ALL, how would you do it? There is no **Save all** command in PaintShop Pro, but don't worry. You can go to **Window > Close All** and you will be prompted with a window listing all the unsaved images and a checkmark beside them all.

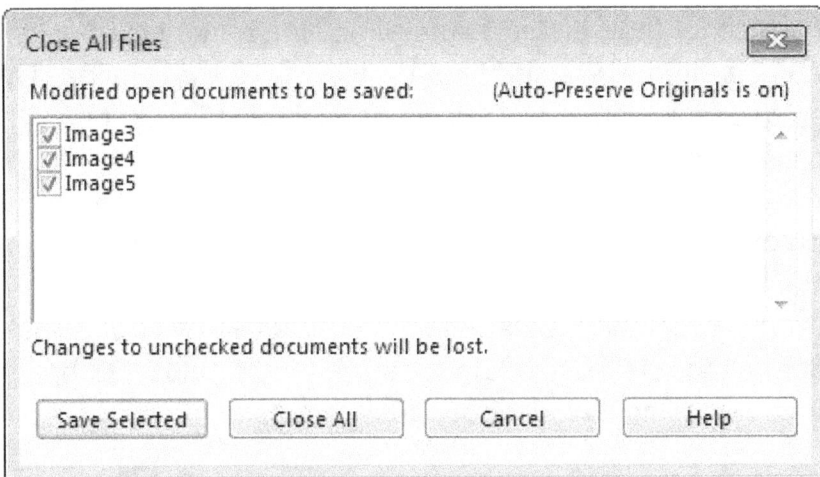

You want to save them all? Just say so on that window and PaintShop Pro will bring up the **Save As...** dialog window where you can choose the location and the name for each file to save, one at the time. Don't worry, you won't lose your images.

Crop Floating Toolbar

If you are using a newer version of PaintShop Pro, notice that you get a floating toolbar right on your project while you are cropping. This can be convenient as it will let you accept the crop, add guides for the rule of thirds, offer some presets, and more, right there. On the other hand if you find it annoying, you can remove it. Go to **File > Preferences > General Program Preferences** and under the **Transparency and Shading**, you

can uncheck the box for **Enable Floating Crop Toolbar**. That simple! And if you want it back, well, you know where to add the check!

With PSP2019, there are even additional functionalities added to that bar where you can add **Instant effects** and **Depth of field**. So maybe you will be happy to keep it floating.

Guides or Grid

Under the View menu, you have two options to help you align elements: the **Guides** and the **Grid**. What is the difference?

The **Guides** are placed at specific locations, one by one. You can have one at 20 pixels, the other at 200 pixels. There is no set interval between them.

The **Grid** will offer a regular interval between each line, whether it is horizontally or vertically. You cannot add **Grid** lines individually. Although you can change the spacing between the horizontal and vertical lines, they will always offer a regular grid pattern.

Which one you choose will depend on what you need to accomplish. They can both display on your image, and they can both be "snapped to". The main difference is their placement, regular or irregular.

Adding Icon Shortcuts

Even though some commands will have a keyboard or a mouse shortcut, some don't and if you want to access them faster, you can always place their icon in a strategic location of your program. For example, the shortcut for the **Repeat** command is simply **Ctrl-Y**, however, I find it a little

inconvenient to use with just one hand since the Y is so far from the **Ctrl** key. I chose to place the icon for that command on top of the **Layers** palette, since that is often where I will be using it.

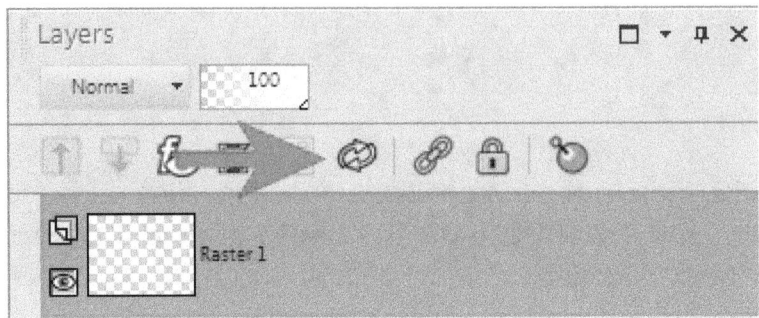

In order to add any icon to a menu or a palette, go to **View > Customize** and in the list of commands, click the one you want, and drag it where it will make sense to you. Now, you have it accessible in one single click.

Essential or Complete Workspace

Starting with PSP2018, there are two ready-made workspace, **Essential** and **Complete**. By default, the **Essential** workspace is selected and unsuspected users might find that this "new" workspace is missing a lot of tools and commands. It is intentional as it is meant to help new users not to be overwhelmed. However, if you are already familiar with PaintShop Pro, you might be looking for those specific tools or commands and wonder if they are gone.

When you start your PaintShop Pro on the **Home** page, make sure to choose the **Complete** workspace, and you will be back in familiar territory.

With PSP2020, a third workspace was added, **Photography**, but you are unlikely to end up on that one by accident.

Binding Scripts

Scripts can be great time-savers, but accessing them might take some time as you need to find it in the drop-down list in the **Scripts** toolbar. You can associate an icon to a specific script that you are using often, and then add that icon just like you would add any other icon to your menu.

Go to **View > Customize** and choose the **Scripts** tab. Select the script you want to bind and one of the available icons (they likely won't be very meaningful, but hopefully, you won't have too many and you will place them in strategic places to remember). Then, click the **Bind** button. The script will then appear in the bottom pane with the associated icon you chose.

At this point, click on the icon, and drag it where you want. If you want it on a toolbar, you can go directly. If you want it in one of the menu or sub-menu, drag it to that location and hover slightly for the menu or sub-menu open. Then, just drop it where you want it. A time-saver to use a time-saving tool.

Keyboard and Mouse

Although PaintShop Pro allows you to use shortcuts, you never have to use them. This means that you are not stuck having to remember a series of shortcuts only to execute basic commands. However, for the commands that you use very often, it might just save you time, whether you are using keyboard shortcuts or right-clicks on your mouse.

Right Mouse Shortcuts

Many steps in working on a project involve duplicating a layer, merging layers, converting a background layer into a raster, etc. The basic way would be to go up on the menu bar, click **Layers**, pull down the menu and click on the appropriate function. Well, there is a shorter way to go (faster in my opinion). Right-click on the layer you want to duplicate or merge, or convert, and you will get the same menu to appear.

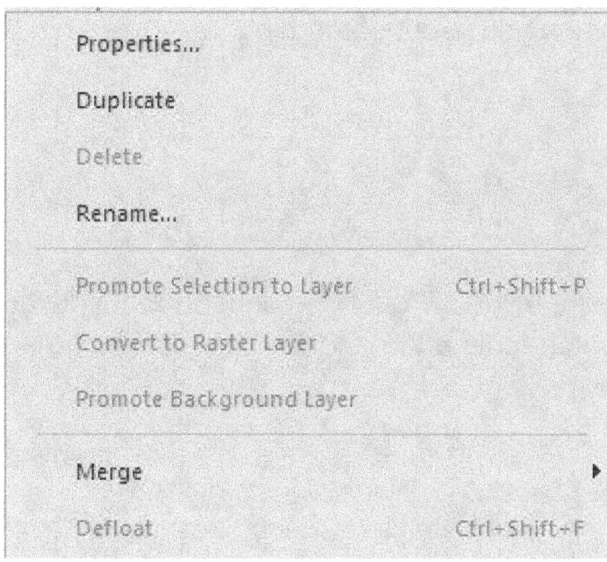

I find that using that way to get to the menu helps you make sure you are actually editing the correct layer. It is also right there if you need to move a duplicate. Save your steps!

Switch Tools

By default, the **Tools** toolbar is on the left of the workspace. You likely work in the center. Do you find yourself wishing you could switch tool without having to move your cursor all the way to the left? There is a way: keyboard shortcuts. Many of the most common tools have a ONE KEY shortcut (no **Shift**, no **Ctrl**, no **Alt**). For example:

M = Move
S = Selection
K = Pick
D = Deform (for the older versions)
V = Pen (think of the tip of a fountain pen)
F = Flood fill
X = Eraser (like when you X out something!)
B = Brush
T = Text
C = Clone
E = Dropper tool

Do you use those? It might be only one second that you will save, every time, but if you switch tools often, those seconds add up and you can save considerable time.

Shortcuts

As soon as you start using PaintShop Pro, start learning the shortcuts. They are not called shortcuts for nothing! The shortcuts I use the most are:

Ctrl-Z : undo (probably the most used shortcut ever)
Ctrl-A: select all
Ctrl-V: paste as a new layer
Ctrl-C: copy
Ctrl-Shift-i: invert selection
Ctrl-D: deselect
F12: Save as...

Of course, there are many more. Check what is listed beside the tools/functions you use the most to see what shortcut is associated with it. Fewer clicks mean smoother workflow and faster result! We all have better things to do with our time!

Repeat

Do you sometimes apply an effect or execute a command and you need to do it a second, or a third or fourth time? Click, click, click. The good thing is that PaintShop Pro keeps the last settings you used, but there is a much faster way to do so: **Ctrl-Y**. If you add a **Gaussian blur** of 10, and you want to repeat it again, just use **Ctrl-Y**. Or if you want to add the same **Drop Shadow**, you can do that as often as you want. Try it!

In PSPX4, there is a bug however, and if you want to apply a particular effect on one layer, change layer and repeat, it will repeat the layer selection instead of the effect. Quite annoying, but that was fixed in PSPX5.

Copy Merged

When you want to work on a flattened version of your current project, you don't necessarily want to flatten the layers. How do you do it? Do you merge the layers, copy and paste them, then come back and undo the merge? That is the long way, but there is an even faster (and safer) way to do that.

For versions up to X1, go **Edit > Copy Merged** (or **Ctrl-Shift-c**).

For versions X2 and up, go **Edit > Copy Special > Copy Merged.** It will copy what is visible AS IF it were merged, but without merging it. Unfortunately, the keyboard shortcut has been removed. On the other hand, a new icon has been added to the standard toolbar where you can click and get to the **Copy Merged** command still quicker than through the **Edit** menu.

In PSPX8, a new feature was added to the Layers palette: **Merge > Merge Visible to New Layer** which allows you to create a merged version of all your layers, without affecting them. And this new layer will be added to your current project.

Changing Shortcuts

Are you using keyboard shortcuts? Personally, I tend to use them, mostly if I can use only my left hand, while using my mouse or tablet with the other. If you are using shortcuts, did you notice that some of them have changed in different PaintShop Pro versions? One of my favorite shortcuts was **Ctrl-V** to "paste as a new image". However, between X1 and X2, that shortcut has changed to become "paste as a new layer" (same as **Ctrl-L**). But you know what? I can still use **Ctrl-V** as a "paste as new image" by reassigning the shortcut.

To change, create or reassign a shortcut, go to **View > Customize** and click on the **Keyboard** tab.

Find the command you want to have with a new shortcut, then press the keys on your keyboard that you want to become a shortcut; if the shortcut you just chose is already assigned to another command, PaintShop Pro will tell you and won't let you assign it to that command, but since you know where it is already assigned, you can go to that command, and remove the shortcut for it, and then come back to the one YOU want, and assign it. Click on **Assign**, and you are done!

Some shortcuts are already assigned to commands you will never use, or if you use those commands, it will be rare enough that you might as well use the long way, through the menu as you would forget the shortcut anyways, so don't hesitate to assign shortcuts that will make sense to you, for the tools and commands you use.

Palettes

PaintShop Pro comes with an array of palettes and menus that will include all the tools and commands you will need. Just like most elements in your workspace, they are customizable and also hide a few features you might not be aware of.

Undo One Command

There are many ways to undo something. The most common way is to use the **Ctrl-Z** shortcut. But this will only undo the LAST command. What about if you want to undo one command you did 10 steps ago, without undoing the last 9? Can you do it? Yes you can. Open the **History palette** (F3) and find the step you want to undo.

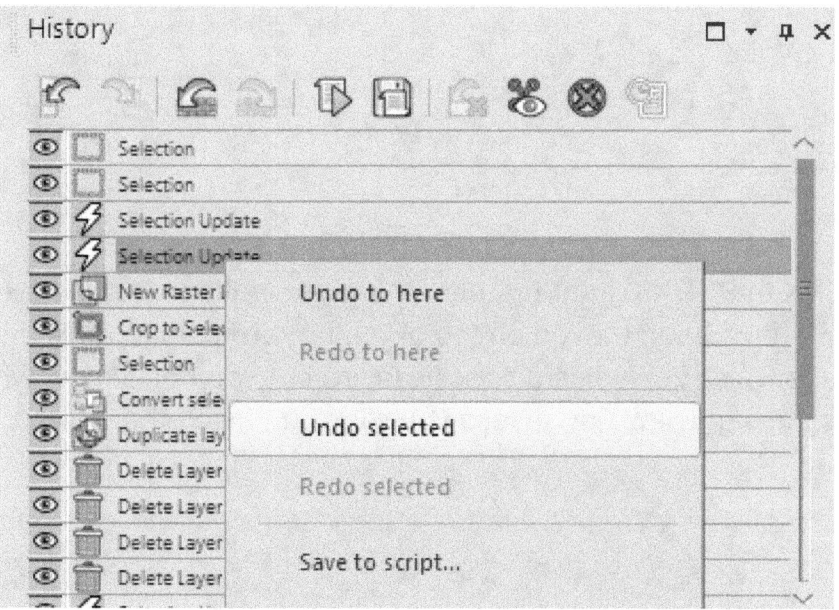

Right-click on that commands, and choose **Undo selected**. And even better, you can REDO that command by choosing **Redo selected**.

Linking Layers

One advantage of using layers is that you can have different elements that will stay editable without affecting others. Each layer can be completely independent from all the others. However, at times, it will be important that two or more elements be positioned in a specific way related to another one. They might need to be aligned together or centered on top of each other. Although one could merge the layers, there is a way to keep them independent while perfectly positioned: linking the layers. Once you have two or more layers linked, you can move them together.

Linking is slightly different depending on the PaintShop Pro version you are using.

For PSP8 and PSP9, the link is a number indicated on the right side of the **Layers** palette, right beside the link icon. By default, all the links are set to **None**, but clicking on that "**None**" will increase the number per click. Any other layer that will have the link set to 1 will be "tied" together, while independent of any others.

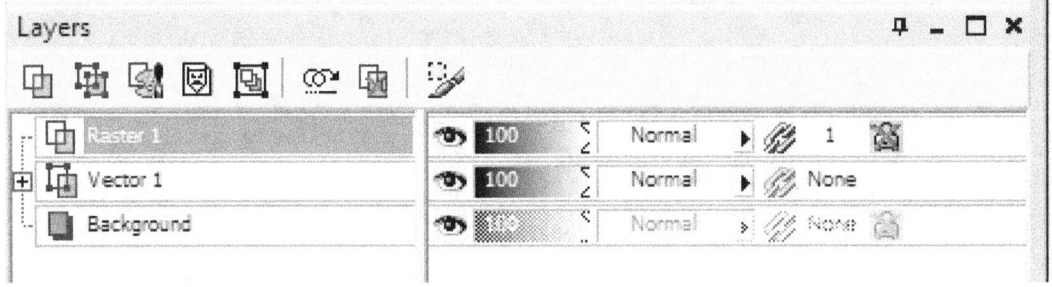

From PSPX to PSPX3, the **Link set** (and other settings that were on the right pane) have been moved on top of the **Layers** palette. This means that you will see which link set is a specific layer, but you don't know which other layer has the same link set, unless you click on those other layers.

Since PSPX4 and up to this day, you no longer see a number to indicate a **Link set**, but a link icon on the right of the layers. Interestingly though, now, if you click on a layer, the **Link** icon will appear and all the other layers linked to this one will also show the same link icon, telling you which layers are linked together. In these versions, you have to select the layers you want linked together (holding the **Ctrl** key) and then click the **Link** icon to get them all linked together.

Locking Transparency

If you want to change the color of an element or a shape, you could be tempted to make a selection around it and then fill with a new color. Unfortunately, the **Selection** will not take into account, the transparency of some pixels on the edges or anywhere else for that matter. This means that filling with a new color will give a flat opaque look on all the pixels that are selected.

If you want to preserve some transparency, on the edges or inside the shape, you can lock the transparency. In the **Layers** palette, there is a **Lock** icon. Once this is activated, each pixel of your image or element will retain its opacity level while you change the color.

PSP8 and PSP9

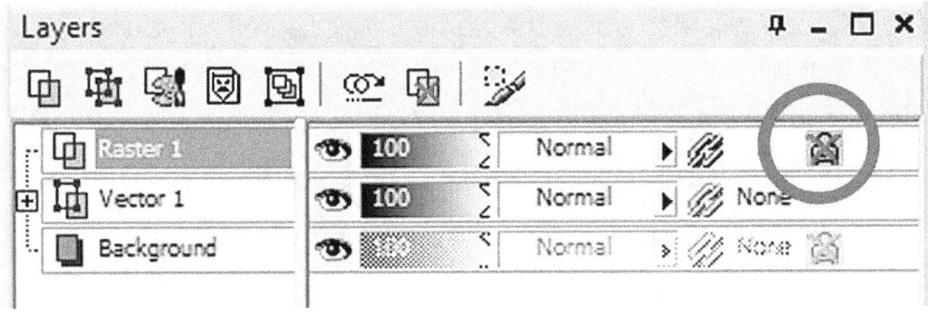

Starting with PSPX, the **Lock transparency** icon is placed on the top of the **Layers** palette. You will see the icon being activated or not when you select a particular layer.

Now that the transparency is locked, you can paint or brush over the area and it will retain all the opacity variations of the pixels.

Renaming Layers

Many projects in PaintShop Pro will require working on a lot of layers at once. By default, when you add a new layer, it will be named Raster 1, or Vector 2 which might not be very useful when you need to find a particular layer to work on it. Although you probably don't need to rename every single layer, you might want to do so for some.

For PSP8 and PSP9, you can go to the layer, right-click and choose **Rename**.

For PSPX and up, just click on the layer name in the **Layers** palette and it will become editable.

For all versions, you can also double-click on the layer thumbnail, and a dialog window will appear, where you can change the name if you want.

New or Classic Materials Palette

From the old PSP8 version to PSPX6, the **Materials** palette and **Material Properties** dialog window has been unchanged and many users have become very comfortable with it.

When PSPX7 came, a new palette and dialog window was introduced which added some very interesting functionalities for the users.

Although this was a great addition, for many users, it was not welcome or it was overkill as they didn't need all those new features.

In PSPX8, an option was added to the **General Program Preferences** to revert to the **Classic Material Properties** if the users preferred. This is a simple checkbox available in **File > Preferences > General Program Preferences > Palettes**.

Which one do you prefer?

Grouping Layers

Do you sometimes have a lot of layers for a particular "element" and want to reduce the opacity to all of them, or apply a blend mode and end up having to do it one by one? There is an easy way: **GROUP** them. While holding the **Ctrl key**, select all the layers you want grouped and click on the icon for **New Layer Group** or go through the menu **Layers > New Layer Group**.

The icon for the **New Layer Group** has moved in different location depending on your version of PaintShop Pro.

PSP X4 and up

PSP X-X3

PSP 8-9

All the layers you have selected will be moved (if needed) inside a new group. You will see a dialog window prompting you for a name for that group.

Beware that if your layers were not adjacent, they will be moved from the current position, which might yield some surprising results if you are not expecting it.

Add a New Layer Quickly

When you want to add a new layer, you can go **Layers > New Raster Layer.** Or you can click on the **New Raster Layer** icon above the **Layer** palette (in versions up to X3) or below the **Layer** palette (for versions X4 and more recent). In all cases you get the **New Raster Layer** dialog window and have to accept the default (usually). Right? If you were to hold the **SHIFT key**, you can bypass the dialog window. If you use the default settings all the time, why bother with it? Saves you one click, but those "one click" really add up over time. This trick also works for any new layer (raster, vector, etc.) and even **New Layer Group** and **Adjustment Layers**.

PSP X3 and older

PSPX4 and up

Color Coding Layers

Did you know you could color-code your layers? Imagine that you are working on a complex project and have many layers related to a particular element or section of your project but you cannot have them all adjacent to each other. Renaming the layers? That might be an option. But if you are a very visual person and would like something more obvious than reading the names, you can add a color to the layer in the **Layer Palette**. How? Double click on the layer, and when that **Layer Properties** dialog window appears, look for a checkbox at the bottom called "**Highlight in Layer Palette**". Once

you check that box, there is a little swatch on the right that will allow you to choose any color you want to highlight the layers.

Brightness

You surely know you can adjust the brightness of an image or element with the **Adjust > Brightness/Contrast > Brightness/Contrast**, but you can also adjust it with an **Adjustment layer**. This will allow you to change that brightness later without having to go through 50 undo's. Do you use **Adjustment layers**? They won't modify the image so you can delete the adjustment and get back to the initial image.

Note: all the **Adjustment** layers will apply to everything below their location in the **Layers** palette. If you want to apply the brightness or contrast to only one layer, create a group with it; it will then apply to only the layers below it inside the group. If you use **Adjustment** layers often, you might want to use these free scripts[12] that will automatically create a group for you.

[12] https://creationcassel.com/adjustment

Stitching Images

Sometimes, you might need to overlap two sections of an image to make a larger one. Maybe you needed to take screenshots in two separate segments and want to make a single image. How do you make sure that you have perfect alignment? Simple: layer the two image sections as two layers, set the **Blend mode** of the top layer to **DIFFERENCE** and as you get closer to the perfect match, you will see more and more black. When everything is black, it is perfectly aligned, and you can set the blend mode back to normal. Use your cursor to move but you can also activate the move tool and tweak with the arrow keys to move one pixel at the time.

Beware that this is not meant to stitch different photos together to create a panoramic scene, but only if you have images of different sections of a single image, like if you are scanning in different sections (although this still requires that the alignment be identical between different scans), or screenshots of larger images on screen.

Red Selection

In PaintShop Pro, if you **Edit Selection**, you will get a reddish color to show where the selection is. But what if you need to edit a selection and your project is red. How will you see it clearly? When you edit the selection, you will see that the selection becomes a "floating layer". Double-click on that layer and the **Layers Properties** dialogue window will appear and will allow you to change the red to another color that might be more suitable and contrasting for your particular project.

Notice that you can also adjust the **Opacity** of this **Overlay**, which is set to 50 by default.

Multiple Undos

It is very common to work on something and change our mind and undo it. That is the beauty of digital scrapbooking (or graphics). However, if you have been working a lot on a project, and you decide you want to undo many steps, you can click the **Undo** button repeatedly, until you get to the step you wanted to reach but you can also use a faster method: the **History palette (F3).** In the **History** palette, all the commands you used are listed, in order, so you can scroll, and find the "new layer" command you want to reach. Click on the eye right beside it and magically, all the previous steps will be undone and you will be just at that point in your project. Interestingly also, if you work on more than one image, the history is specific to each

image so you would only have to undo the commands related to that particular image.

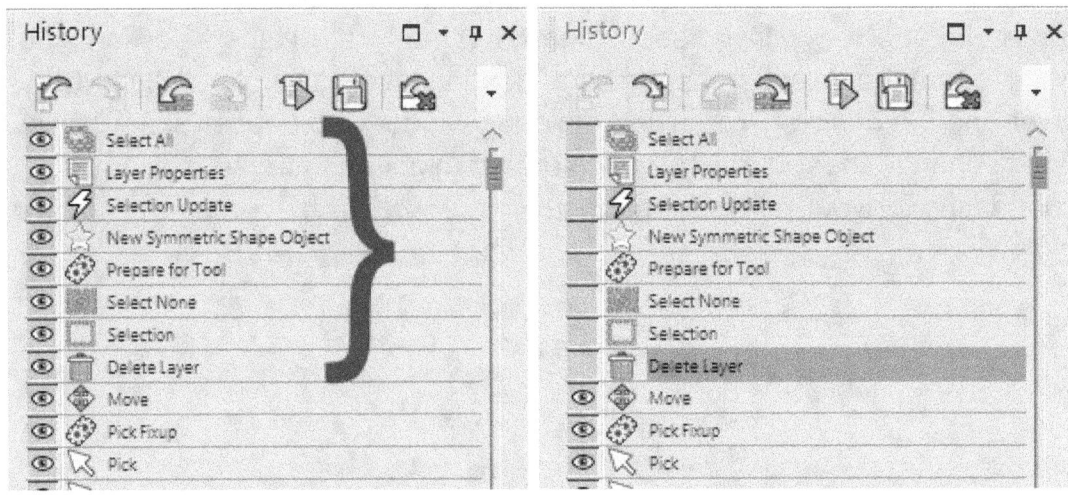

Duplicate and More

Starting at version X4, you were able to select more than one layer in the **Layers** palette, while holding the **Ctrl** key. Did you know that you could use that trick to duplicate multiple layers at once?

Select several layers holding the **Ctrl key**, right-click on one of them, click on **Duplicate** and you will have a duplicate of each of those layers, and furthermore, each duplicate will be right above the original layer, even if the selected layers are not adjacent. This could definitely be a time saver.

No Thumbnail Wanted

If you have a tendency to work with lots of layers, it is possible that the view of those thumbnails in the **Layers palette** are just in the way since you have so much to scroll to go from one layer to another one in the project. Although having a thumbnail for the particular layer is often more convenient, it is also possible to remove it, to save space. To do so, go

to **File > Preferences > General Program Preferences** and under the **Palette** tab, uncheck the **Palette Thumbnails**.

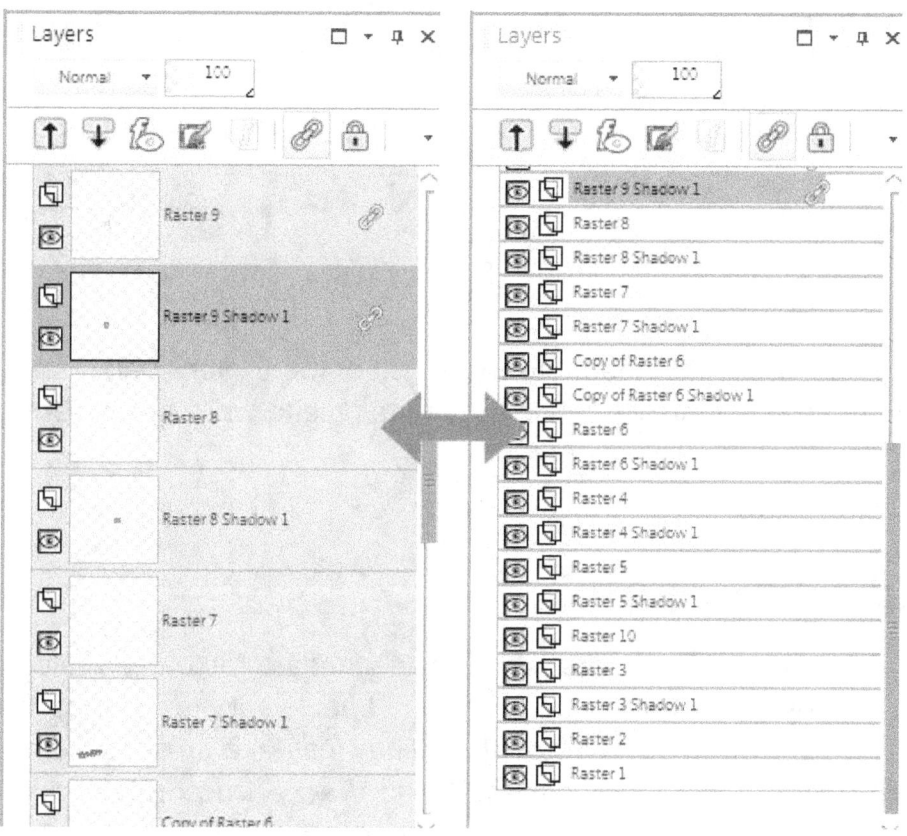

That's all. And if you change your mind, you can just check it again. Remember that if you hover over the layer, you will still get a preview so you will not work completely in the dark.

Another way you can customize your **Layers** palette is to add the right pane that was changed in version X.

Here is the **Layers** palette in version 9, which you can replicate if you want, with any recent version. See where the **Opacity**, the **Blend mode** and more details are available directly adjacent to the layers themselves.

From that point on, the default arrangement of the **Layers** palette is to have many of the settings displayed on top of the palette while one layer was active.

Need More Room?

Although PaintShop Pro comes with some standard toolbars, sometimes, the commands in those toolbars are just not necessary for your particular type of work or your personal workflow. They just take up space. Do you want more room? Just remove them. Go to **View > Customize** and while that window is open, grab the unnecessary command and drag it down to the center of your empty workspace. And that's it. It is gone. Don't worry if you ever need it once in a blue moon, there is always a way to get the same commands somewhere else. And if you change your mind and really want it back in the menu, just grab it from the **Customize** window and put it back in place! It's that easy.

Need Even More Room?

More and more PaintShop Pro users have larger monitors, but we always want more space to work. Do you know you can hide your palettes and have more room to work? This is a matter of personal preference but if you

need more room on your work area, just find the push pin icon on top of each palette (like the **Materials** palette, the **Layers** palette, etc.) Click on that icon and the palette will hide behind a simple tab when not in use. And when you need it, just hover your cursor over it and it will come back for you.

Menus

With the number of tools and commands available in PaintShop Pro, it just made sense to organize them into menus that you can easily access from the top of your workspace. Although they are predefined, there are ways you can customize menus even further to make your area more suited to your own workflow and preferences.

Menu Animation

Typically, when you want to use a menu, you will click on it and it will roll down. That is the default behavior, but did you know that you can go a little fancy and add some animation to the menus? They can unfold, slide or fade. Do you want to test those? Go to **View > Customize > Menu**. Check the **Animation** options at the bottom, and choose a different one. Those animations are fairly subtle, but you might prefer another one?

Help in the "Wrong" Place

If you come from an older version of PaintShop Pro, you must be used to having the **Help** menu on the far right of the menu bar. That is commonly the case with just about any other program. However, starting with PSP2018, Corel has added other menu elements to the right of the **Help**. Does it annoy you? If not, don't worry, but if it bothers you, you can move it. Simply go to **View > Customize** and while that window is open, click on the **Help** and drag it where you want it. You can do that with any other menu element if you want to rearrange them. Another way that PSP is customizable based on your own workflow.

Custom Menu

You surely know that you can create custom toolbars with your PaintShop Pro. However, did you know you could ALSO create custom MENUS? You know, those menus like you have with **Adjust**, **Effects**, etc.

Go into **View > Customize** and in the first tab (**Commands**), you will find **New Menu**.

Then, simply click and drag that **New Menu** where you want to place it on your menu bar.

Note: If you create custom menus, make sure you save your workspace so you won't have to redo everything if you have to reinstall PaintShop Pro!

Contextual Menus

Right-clicking on a particular layer in the **Layers Palette** lets you access some commands faster than going through the menus on top. But did you know that you have more contextual menus than that? Right-click anywhere in the workspace and you will have one menu that allows you to create a new image, or open a file. No need to go all the way to the top left of your screen.

If you have an opened image and you right-click on the top part of it (or on the side if you have tabbed documents), you can cut, copy and even copy merge (I wish I knew that as in more recent versions of PaintShop Pro, copy merged doesn't have a keyboard shortcut anymore!). And best of all, you can also customize those menus so you can get your most often used commands, right at your fingertips, literally!

Colors and Textures

If you create any element with PaintShop Pro, you will want to use colors, gradients, patterns and textures. There are a lot of options you can use to create your projects but also a lot of shortcuts to work faster.

Quick Color Change

You probably know how to pick a color with the **Dropper** tool. You can pick the foreground with the left click, and the background with the right click. And when you want to flood fill, you can also use the right click to choose the background color. Just a little shortcut to go a bit faster! This is great if you need to use both colors almost at the same time to fill here or fill there. You can also use this left or right-click trick with the **Brush** tool to use both colors alternatively.

Create Your Own Texture

PaintShop Pro comes with several textures but a designer never has too many. If you find a picture of a texture that you like, you can make it available in your PaintShop Pro in a very simple way: just save the image in your **Texture** folder and voilà! Easy? Sure! PaintShop Pro can handle files in various formats, like .psp, .pspimage, .jpg, .bmp, and .gif.

Shadow on Separate Layer

The old JASC PSP 8 brought a new and very useful option in the **Shadow** window. Now, you can add the shadow on a separate layer. What good does that do? It gives you so many more options. With a shadow on a separate layer, you can actually modify the shadow itself, and create the illusion of the paper corner lifting from the background or you can play with

the shadow of a straight pin that seems to be pinned upright with a long shadow going from the point of insertion to the outside getting blurred more and more. It gives you many options that were unavailable before that version.

Using a shadow on a separate layer also has another advantage: if you are unsure of what type of shadow you need for a page or a preview, you can always delete the shadow if you are not happy with it and start again, something that is near impossible if the shadow is stuck on the same layer as the object.

Shadow for a Vector Layer

Normally, you can only add shadows to a raster layer, so if you have some text or some preset shapes that you want shadowed, you would likely need to convert them to raster layers. However, this will eliminate the possibility to edit your vector element later. That is not always what you want. There are two ways you can address this situation.

First, you can duplicate your **Vector** layer. Then, you can safely convert the duplicate to a raster layer and add a shadow on its own layer. Now that you have the shadow, slide it under the vector layer and it will look just like you added the shadow to it. Make sure you link both layers in case you need to move them.

The other method is also to duplicate the vector layer and convert the duplicate to a raster. However, you can use that layer as a shadow, by adjusting the **Brightness** to -255 to turn it all black. Then, move it below the **Vector** layer and adjust the blur and the opacity as you would have in the **Drop Shadow** settings. You can also move it as you need. Again, once you are done, link the **Vector** layer and the shadow to make sure they stay together.

Quick Thread Texture

Sometimes you might have a line that should be a thread and you are looking for a thread texture. You don't have one? No problem. Just add 10% noise to the line by going to **Adjust > Add/Remove Noise > Add Noise**. Simply add a **Bevel** and some shadow and you will have a thread texture in the end. Of course, that will mostly work when you have small threads, as it won't work for large "rope" but it is a good way to add texture to a thread you drew with the pen tool. One thing to remember: a normal thread will be so small anyways; you really don't need to get fancy. In the following example, the thread is actually much larger than it would normally be.

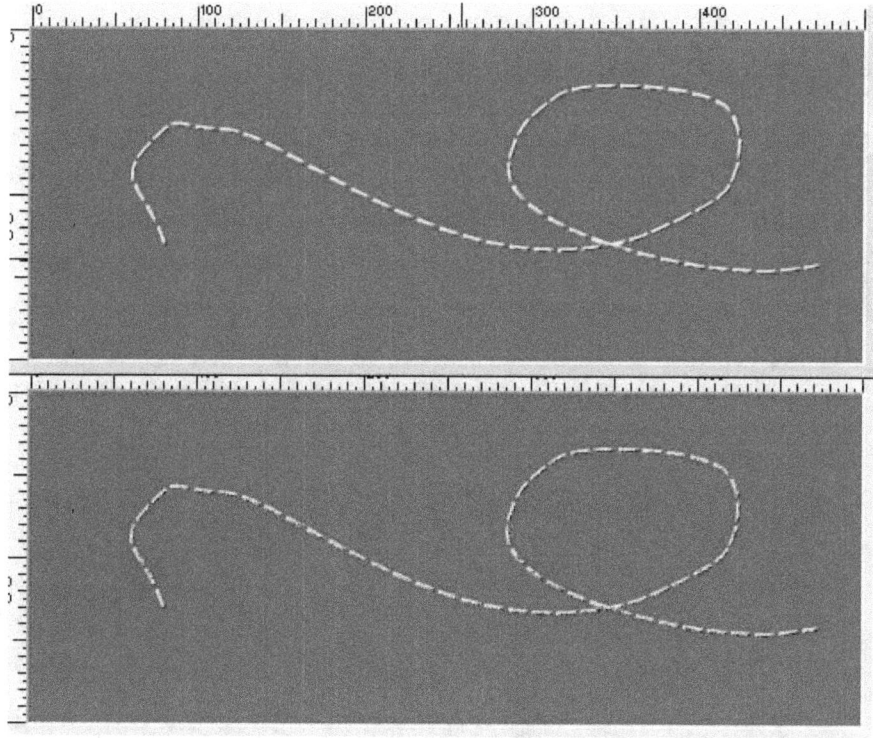

Shadows

Whether you are creating layouts, making previews for a digital kit, or working on various other realistic projects, shadows are extremely important. Let's remember that DIGITAL design has no actual thickness so you have to simulate that 3D effect. Use shadows and lighting to achieve that goal. But remember to be consistent. All the shadows and lights should tell the viewer the same message. If one element seems to have light coming from the right, and the other element seems to come from the left, the overall look will be odd. This can make or break a composition. If you create a layout, it will not make the viewer go "Wow!", and if you make a preview, it might even affect whether the viewer will consider buying the kit or not! And this is not exclusive to PaintShop Pro users either!!!

Colorizing White Elements

If you ever tried to colorize an element that is pure white, you must have noticed that it is not possible. Why? Simply because "white" is like having no pixel to color! So, if you have a white ribbon and you want to colorize it, how do you do it? Very simply by adjusting the brightness first. Depending on how bright/pastel you want the new color to be, you can play with the settings. A very light grey (brightness of -20) will give you a base for a pastel color, while a darker grey (brightness of -70) will give you a more sustained color. Easy enough for you?

Blurred Photos?

Sometimes, you might have some pictures you want to use in a scrapbook. They might not be the best as you find they are a bit blurred, but you still like them, maybe because they are special in their own way. Although you cannot make a perfect picture out of a blurred one, you can certainly edit it to get something even better. There is a tool that can do that. Under **Adjust > Sharpen > Unsharp Mask**. Just use the default settings and you should see some improvement. Play with the settings and you might find other interesting effects.

Easy Emboss

Add a touch of embossing to your paper element very quickly. Create your text as a selection and simply add a bevel to the paper layer. It can be that simple! If you want a more intricate design, you might have to create the whole decorative element and then, **Select** all (Ctrl-A), **Float** it (Ctrl-F), **Defloat** it (Ctrl-Shift-F), and activate the paper layer. Either way, it is easy and quick. You can even use this as a way to add some watermark on your projects or your photos if you need to post them online.

Use Those Patterns

You can create a tile on your workspace, and then retrieve it in the **Materials** palette under **Patterns** without having to save it. Place a shape, a design, even a stamped brush on a small image (100 x 100 or 200 x 200 depending on the design) and you can use it to flood fill a whole page, or use it for smaller fill. Change the angle and the scale for a lot of variety. This is a quick way to have a new pattern. And PaintShop Pro will use whatever is visible on that image, whether it is a .jpg image or a .png with a transparent background. If you are working with layered images, you can hide and unhide layers and be able to use the visible result as a pattern.

Blur but Not All

If you like a fantasy look in a layout, or just to add a soft look to a photo, you probably have tried to add a soft blur, but that does exactly what it says: it blurs everything and you kind of lose some details, as if the photo was in the fog. Well, you can have some blur but still keep the edges more definite. Simply put, try this: **Adjust > Add/Remove Noise > Edge Preserving smooth**. Yeah, who would have guessed to look in the **Add/Remove Noise** to find a blurring tool?

Sunshine Photos?

Taking pictures in different lights can give a weird color to some photos. Usually, photos taken outside will have a good color, but you might be surprised on how you can add a little sunshine with one setting. You can try **Adjust > Color Balance > Grey World Color Balance** then choose the **Sunlight** setting. See how it brightens your photo!

If you are using a version of PaintShop Pro that does not SEEM to have that setting, don't worry, you still have it. Go **View > Customize** and in the **Command** tab, scroll down to the last one and select "All commands" on the left, then, find **Grey World Color Balance** on the right. Click and drag that command to anywhere on your toolbar and you have it available. In previous versions it was under **Adjust > Color Balance**, so you might want to place it in the same section or just inside **Adjust > Color** (since the **Color Balance** label might have been changed in those versions).

Washed Out Colors?

Do you sometimes have photos that are just a bit dull, and the colors look faded or washed out? If you ever tried to play with the brightness and contrast, you might find it is not always giving the best result. One other tool that is available is here: **Adjust > Brightness and Contrast > Level**. Although the window is a bit different depending on your PaintShop Pro version, you will find a line with 3 sliders: one on each end and one in the middle. For washed out colors, move the LEFT slider a bit toward the middle. For dark colors you can use the RIGHT slider, but it might not work as well. You can use this feature for your photos, of course, but also for any scrap paper or element you want to brighten.

Recently Used Material

Do you sometimes need to use a specific color that you used yesterday but you do not have the base where that color was picked initially?

You can get those colors easily by right-clicking on the **Foreground and Stroke Properties** or the **Background and Fill Properties** "swatches" and

it will bring up the last 10 colors, gradients or patterns you used, so you can just grab it there.

However, if you right-click on the smaller **Foreground and Stroke Colors** or the **Background and Fill Colors** "swatches", you will get the last 10 solid colors only.

Quick Translucent Surfaces

Do you like the look of translucent ribbons, or other elements? Do you know the quickest way to get a translucent surface? Using the eraser? Nope, that is tedious. Easier than that: in the **Material Properties** window, when you pick a color (or gradient or even a pattern), on the right side of the window, there is a **Texture** option. Check the box and pick a texture from the drop down menu. This will basically act like an eraser brush: the darker the texture is, the more transparent your surface will be. And you can adjust the size and the angle of the **Texture** so you can even use some distinct patterns! And then, just flood fill with that new "material".

Wrinkle-Free

Playing with different tools and commands, I found this little trick to smooth images, and I have mentioned it, but without realizing this use: **Edge Preserving Smooth**. You can find that command under **Adjust > Add/Remove Noise > Edge Preserving Smooth**. Maybe that is what you need to remove wrinkles to Aunt Margie?

Quick Glow (1)

Once in a while, you might want to have some glow around an element. One fast way to do that is by adding a drop shadow in the color of your choice, with a **Vertical** and **Horizontal Offset** of 0, and **Opacity** of 8 and a **Blur** of 25. You might need to duplicate that layer a few times if you want the glow to look stronger.

Glowing

Quick Glow (2)

Do you know another fast way to create a glow around an element? With PaintShop Pro version X2 and later, there is a new tab in the **Layer Properties** called **Layer Style**. Double-click on a raster layer to see this window appear. There, you have a few different layer styles including **Outer Glow**. Then, you have a few settings available, including the size, opacity and color of the glow. This will be applied on the same layer as the object though, so be careful when you apply it.

Quick Glow (3)

Although you can create an outer glow with the **Layer Style** (since version X2), this has a few drawbacks: first of all, it is on the same layer as the object so it is harder to manipulate; second, it won't work with earlier versions of PaintShop Pro as it is not even an option that existed then. So what to do? You can create a similar outer glow with the **Drop Shadow**, as explained above, but there is also another way. You can duplicate the element itself and apply an important **Gaussian blur** to the bottom layer. If you want to change the color, you can increase the brightness to the maximum and turn it white, or less to turn it grey to finally colorize it. That is your choice.

You could also change the color of that layer by using the **Transparency Lock** and paint over that glow layer in any color.

Instant Color Picker

What is the fastest way to pick a color? With the **Dropper** tool, of course. But if you are in the middle of using another tool, that means you have to click on the **Dropper** tool, pick the color, and come back to the tool you were using. But there is an even faster way: hold the **Ctrl key**, and your cursor magically becomes an eyedropper for you to pick the color you want. And you can choose the **Foreground** color with the left-click and the **Background** color with the right-click. Isn't that quick?

Transparent Background

Whether you have a color preference or visual preferences, you can change the familiar white and grey checkerboard that is visible to show transparency of your work. Simply go **File > Preferences > General Preferences** and check the tab "**Transparency and Shading**". And you can change the colors, and the size. You can find various presets, or create your own if you prefer some different colors.

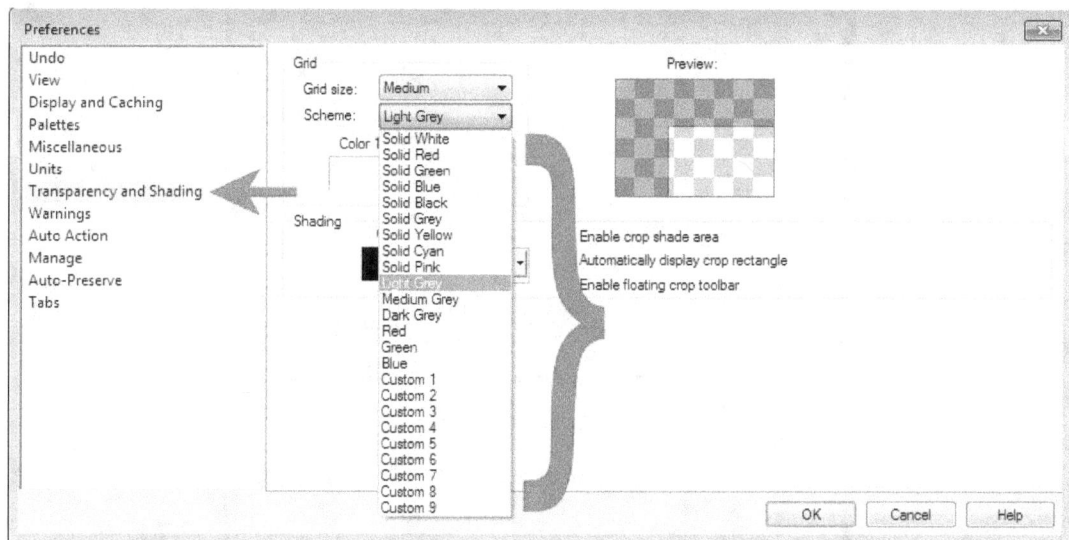

Turn to Greyscale

There are two main ways to turn a color image into a greyscale. Did you know? The first one is to desaturate while using the **Colorize** command and setting the saturation to 0. The other way is to go through **Image > Greyscale**. Which one did you know of?

Note that if you use the **Image > Greyscale**, it will also change the color of all the layers in your project, so use caution with this command.

Color Coding

When you work with colors, are you using HSL? RGB? Hex? Do you know that PaintShop Pro can generate color codes differently and you can change the default setting if you want? When you use your **Color Picker tool**, do you get numerical values for the RGB? Would you prefer to have something else? Look at this:

On top is probably what you see: numbers for **RGB**. On the bottom, you have some **Hex** code for each. Did you notice that if you put the codes for **R** and **G** and **B** together you get the **HTML** hex code? How do you get those? Go in **File > Preferences > General Program Preferences** and under the **Palette tab**, you can click the button for **Hexadecimal display**. What else would that do? Check what you would see when you use the color picker:

```
R: 255          R: FE
G: 232          G: E8
B: 175          B: AF
O: 255          O: FF
     100%           100%
```

Do you find more use with the **Decimal** or the **Hexadecimal** values? It is up to you, and you can change them if you need to.

Shadow Color

I often get asked if one should really use black as a shadow color or if it should be a grey color. Do you want the long or the short answer? In fact, it should be both. Right! How can it be black AND grey at the same time? Simple: a grey shadow is usually made of a black one, with lower opacity. It means, you can use black in the **Drop Shadow** dialog window, and it will seem grey on your image, while in fact, the end result will be neither black nor grey, but will show as the color of the background (just darker like you would expect).

Color Inside the Line

Did you ever color while holding your fingertip on the line to make sure your pencil or crayon would not go over the line? There is a way to simulate that fingertip idea in PaintShop Pro. Try selecting inside a shape with the **Magic Wand**. Now, you can color within the "line". Of course, you also have the option to color on a separate layer (much easier to make a correction!). This is a perfect tool to use if you want to colorize an element!

Quick Silhouette

Do you know the quickest way to get a silhouette shape in PaintShop Pro? Just lower the **Brightness** to -255 on the .png image. This is a fun way to use clipart that have a definite and identifiable outline. I have used that trick to create a matching game for kids. And if you want, you can either match the colored and black silhouette, or make it a black on white versus white on black silhouettes.

Pick a Color Outside PaintShop Pro

If you are looking to pick a color from something that is NOT on your PaintShop Pro, you cannot use the **Dropper** tool right? WRONG? Yes you can. You can pick a color of anything on your monitor even if it is out of the PaintShop Pro window (even a different monitor). Make sure that the color you want is at least visible, so resize/move the PaintShop Pro window first. Hold the **Ctrl** key, hover over the foreground or background swatch. You will notice that little window following your cursor with the HSL and it will say "**Sampling screen**". Now move the cursor anywhere outside of PaintShop Pro and it should just grab the color from your desktop or from another program.

A Textured "Bug" on Purpose

A while ago, I discovered what looked like a bug because it does something that does not make sense, but since it is there, I think it is a cool "bug" to use. You already know that you can choose a texture in your **Materials** palette and it will be applied to the color, gradient or pattern. You also know that if you are using the paint brush with the material AND a texture, it will apply the material AND the texture. That is a given. You knew that. BUT, do you know that you can now erase with a texture even without a textured

brush tip? Yes. Here is the trick (or should I say, the "bug"). Choose a texture in the **BACKGROUND** material. It does not matter what color you are choosing, just focus on the TEXTURE.

Now, to test it, use your plain **Eraser tool** on any dark solid color. Do you see what I see? And this "bug" works on all versions I tried, from PSP8 to PSP2019 (which is the current version at the time of this book).

So in the end, is it a bug or a hidden feature? After much research, it seemed to have been a documented feature in OLD JASC versions of PaintShop Pro, but that looks like it was ignored after a while so recent users likely don't remember it. I never knew about it!

Black and White and Grey

Although you can always open the **Material Properties** dialog window, you can pick black or white or grey simply by clicking under the colors if you have the **Frame** or the **Rainbow** tab active. Just one click and you have it. This tip is valid for all versions up to PSP 2019 (the most recent version). However, this ONLY applies if you are using the **Classic Material Properties** as selected through the **File > Preferences > General Program Preferences > Palettes**.

If you are using the new **Materials** palette, you can still get black and white and grey on the top line of the **Swatches** display:

Editable Effects

Normally, if you apply a **Drop Shadow**, even if on a new layer, you cannot come back later, and edit it; you have to delete it and reapply it. With the **Layer Style**, however, the same **Drop shadow** applied can be changed later, even if you have saved and closed your image before. Isn't that convenient?

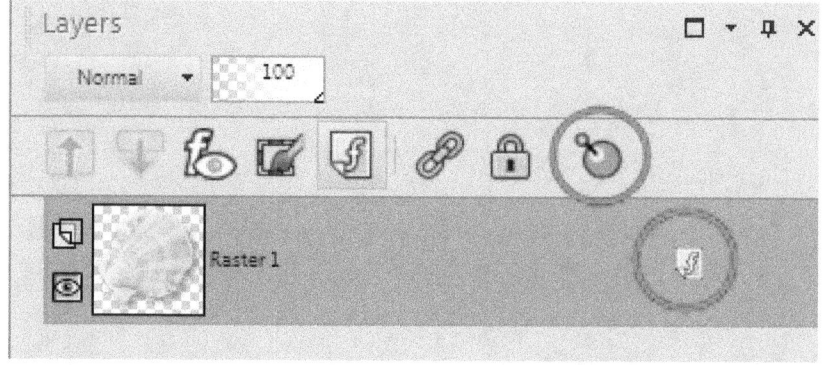

Of course, you could have added a drop shadow on a new layer, deleted it and re-added it, but what about a **Bevel**? That is something that you cannot adjust later on, but with the **Layer Styles**, you CAN!

But of course, that is only with PSPX2 and newer!

Content and Supplies

PaintShop Pro is a great program to create images and various projects, but it also uses a lot of resources, whether they are coming from the program itself or from outside sources.

Photoshop Gradients

Did you know that you can usually import Photoshop gradients into PaintShop Pro? Go to the **Gradients** tab of the **Material Properties** window, and find the **Import** button. Then, locate the **.grd** file you want to import and that's it. One **.grd** file can contain many different gradients! You might get an error related to the naming. If so, just add a letter or a digit to the name so you won't have two files with the same name. Although this works most of the time, it can happen that the import is unsuccessful. I am not sure why but it CAN happen. Sorry for the bad news!

Facebook Images

Do you have relatives who posts photos on Facebook and you would like to include some in various projects? One word of advice: DON'T. Don't use a photo that you download from FB because, probably in order to prevent people from stealing photos, FB considerably reduces the size and quality of the photos. It reduces them so that it is sufficient for displaying on your monitor, but to use it in a graphics or scrapbook project, they will be really small and bad quality.

Old JASC Resources

If you have been using PaintShop Pro for a long time, you might have started when it was owned by JASC, and have some supplies that seem to have a different extension than what you see now. Can you use them in recent versions? Yes you can. Some of those extensions would be **.tub** (for picture tubes) and **.jbr** (for brushes) and **.jsl** (for preset shapes). How do you use them? Just the same way you would use the current files; put them in the **Picture tubes**, **Brushes** or **Preset shapes** folders and that's it! So don't delete them!

Note that Brushes from PSP7 and before need to be imported with **File > Import > Custom Brushes**. Preset shapes from PSP7 and before cannot be used as is in more recent versions of PSP.

Saving New Supplies

If you are getting supplies, like **Picture tubes**, **Frames** or **Brushes**, don't try to "install" them or "import" them. If they are in **.PspTube**, or **.PspFrame**, or **.PspBrush** format, just save them in the correct folder. If you double-click on them, it won't install them. In fact, it will open one version of PaintShop Pro, but won't help you use those supplies.

Organize Your Supplies

If you tend to download supplies from various sources (brushes, scripts, tubes, etc.) keep them in separate folders by source (either by creator, by store or by site). Once you need to use them in PaintShop Pro, there will typically be a drop down list of folders for you to choose. That means that if you know you are looking for a brush from creatorX, you can pull down the folders list, select creatorX, and have only those brushes to scroll through instead of ALL of your brushes (which could be a lot if you are like me!).

You can also use this approach to categorize your supplies. You might have *Grungy* brushes, or *Watercolor* brushes, or **Corner** brushes. The same goes for **Picture tubes**, as you might have *Holidays* tubes, *Rope* tubes, *Chain* tubes, and so on.

This works for presets, shapes, brushes, scripts, picture tubes, line styles, etc.

Mask Files

Although you might expect to use files with the .PspMask extension as masks, you can also use any file that is a .jpg. Even better, you can also use files that are .gif, .png, .PspImage, .msk. Basically, if you have a file that you would like to use as a mask, try it. It might just work as is!

File Locations

You probably know that you can use the **File Locations** under **File > Preferences** to indicate to PaintShop Pro where you are keeping your brushes, tubes, etc. When you are using the drop-down list for the tubes,

brushes, shapes, scripts, etc. there is one icon called... you guessed it "**File locations**".

And this little icon will open the **File Locations** window so you don't have to go the long way through the **File > Preferences**. Just fewer clicks but you always want to save time, don't you?

Photoshop Plugins

Although it is not the case for 100% of the plugins, did you know that a lot of plugins said to be for Photoshop actually work with PaintShop Pro? Check out this article[13] on some major plugins that are promoted as being for Photoshop, with little or no mention of PaintShop Pro. So if you see a plugin

[13] https://scrapbookcampus.com/Photoshop

that looks interesting, read further in the compatibility information, or ask the creator. You might be surprised.

Filter Forge is a huge plugin with thousands of filters available. Although it is advertised as a Photoshop plugin, it works perfectly fine in Painsthop Pro. Read more about it in this article[14].

Open Several Elements at Once

While working on a project, you can easily open several images together, like several buttons, banners or flowers. When you browse to open the first element, if you hold the **Ctrl** key, you can select several elements on the list. Of course, it only works for images in the same folder but it can still save you time that you would rather use to work on your project than to open images one by one, don't you think?

Additionally, if you want to still load all those resources, in the drop-down list for your picture tubes, brushes, patterns, etc. there will be those sub-

[14] https://scrapbookcampus.com/FF

folders listed too. So you can quickly navigate to the correct sub-folder if you specifically want an Easter themed element.

Using ABR Files in PaintShop Pro

As a PaintShop Pro user, you might notice many ABR brushes made for Photoshop are available online for free or for purchase. Since version X5 PaintShop Pro can import those brushes as if they were made for PaintShop Pro. However, if you are still using an older version, you cannot do that directly, but there is a way around it, a bit longer, but still worth the work. Go download the ABRViewer[15] if you don't have it. It is free. Now, open the abr files in the ABRViewer and Export the thumbnails. Just like magic, they will all be converted into PNG files. You can use them like that (which can be very useful) or you can then convert them into PaintShop Pro brushes, with Suz's script, Creating PSP brushes from PNG Images[16]. More detailed steps are available in the Scrapbook Campus as "Converting Photoshop brushes for use in PaintShop Pro[17]"

So, do you have access to download or purchase some neat ABR brushes? Go ahead! Download as much as you want!

Too Many Resources to Load at Once?

You all know that I consider it safer to install your resources in a separate section and NOT in the PaintShop Pro folders that are created by default upon installation, right? And you know that you should then set the preference to retrieve those resources wherever you placed them. Now, are you gathering LOTS of resources like picture tubes, brushes, shapes, patterns, etc.? Maybe you don't need them available all the time. Maybe the egg patterns are not that useful outside of Easter. Then, create SUB-folders

[15] http://abrviewer.sourceforge.net/
[16] https://creationcassel.com/PNG/
[17] https://scrapbookcampus.com/Brushes

for various themes that might not be needed all the time and in your preference, UNCHECK "Use subfolders" (so that PaintShop Pro will not reach for ALL the resources) and set which ones you WANT to use. And when Easter comes, re-enable that sub-folder to access all those themed resources. That will prevent having to scroll through hundreds of shapes, tiles, brushes, etc. to find the one you want.

Scripts in Other Locations

You have all your scripts saved in the same folders, right? And PaintShop Pro is directed to them through the **File Locations**, right? That is great, but what if you have another folder somewhere else, that you do NOT want listed that way? Maybe you just wanted to try someone's script and don't really want it in your "regular" scripts folders. You can still run any of those by going **File > Script > Run...** and then choose any "orphan" script not in those folders with the other ones.

Note: Beware that "trusted scripts" will not run properly with that method. For those, you have to use the old way of saving them in the **Scripts-Trusted** folder and point PaintShop Pro to them that way.

Save Your Resources (1)

Over time, you probably created, downloaded or purchased some PaintShop Pro resources, whether they are picture tubes, masks, scripts, presets, etc. By default, your installation of PaintShop Pro has created a set of folders in MyDocuments and you might be tempted to save all your resources in those folders. That seems logical right? WRONG. Although that is the intended purpose of those folders, I can tell you from experience that it is not the best way to go. If you save all your new resources in those folders, they are at risk of being deleted if you ever need to reinstall your PaintShop Pro (we never wish that, of course). PaintShop Pro has the option to access your resources, wherever you place them. So here is the trick:

- create yourself a folder that you can call PaintShop Pro Resources (or whatever name you want) on your computer drive (anywhere, it does not matter)

- create sub-folders that are named "Masks", "Scripts", "Presets", "Tubes", etc. (you don't have to create them all at first, you can just add more as you need them),or you can make a copy of all the empty folders that PaintShop Pro created in MyDocuments

- in your PaintShop Pro, go to **File > Preferences > File location**

- on the left side, you decide which resource you want PaintShop Pro to find (ex: **Brushes**)

- on the right side you can add the path to the new folder you just created for that purpose

- you can repeat for several types of resources

- and you click OK.

Now, in the event you have to reinstall your PaintShop Pro, you will NOT lose all those resources. Of course, if you download or create lots of those, it is also a good practice to save them regularly on another medium (CD, DVD, EDH, Jump Drive) or through an online storage service since we also know that hard drives CAN fail too. TRUST ME. When my hard drive decided not to work, I literally panicked. Lucky for me, it was not a total failure and it was fixed, but I sure found a way to immediately save my hard worked and hard earned resources!

One additional advantage of this way to store your resources is that you can point several versions of PaintShop Pro to the same folders, therefore you would have access to all the same resources in all of them.

Save Your Resources (2)

Do you know that, by default, whatever you save from your PaintShop Pro like presets, line styles, brushes and tubes will be saved in those folders created by your PaintShop Pro? Before you go any further, take a few minutes to tell your PaintShop Pro otherwise. Go **File - Preference - File Location** and in this window, find where it says **"Save to"**, and point to the folders YOU created.

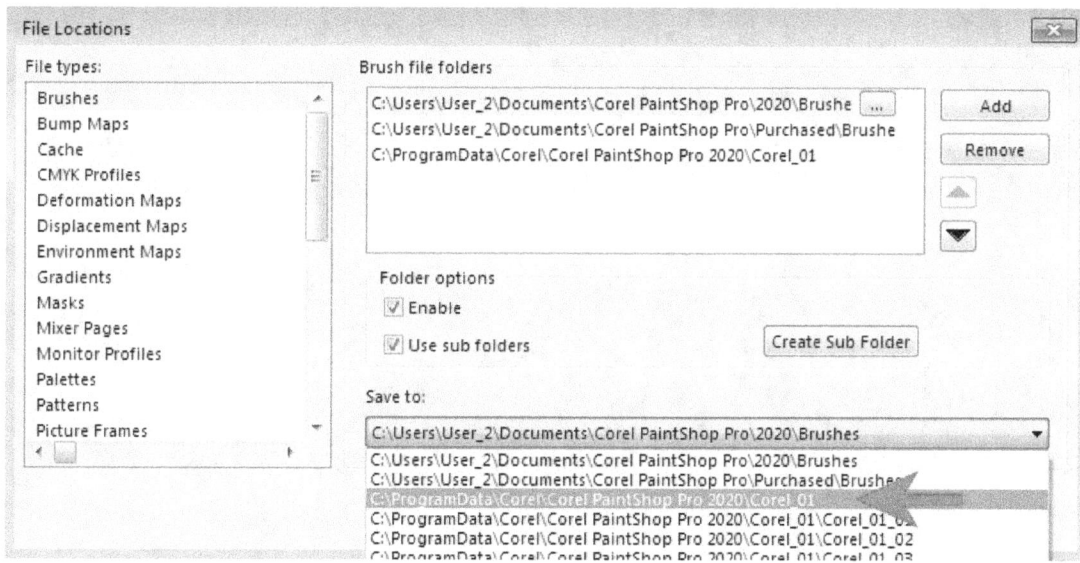

Do that with all the resources you might create. The most commonly created are **Brushes**, **Picture Tubes**, **Presets** but to be safe, do it for ALL of them. It will take a few more minutes, but you won't hit your head against the wall if anything happens to your resources. **Go ahead. Do it**. And while you are thinking of it, check the PaintShop Pro folders in My Documents and see if you have already saved any supplies there. If so, move them to your other folders, and why not then, make a backup of the supplies you already have. Since much of those were created by yourself, if you lose them, you cannot go and buy them again. Trust me!!!

Preferences

PaintShop Pro is not just a powerful program but also one that can be customized to the user's workflow and preferences. Many options are available that a user can choose to change or leave as default. See how you can make PaintShop Pro adapt to you instead of you, having to adapt to an inflexible program.

Saving Your Work Automatically

When you spend hours working on a project, the last thing you want is to lose all that work due to unforeseen events. It can be extremely frustrating to be about to finish a project, to see the computer shut off, or the program freeze and all those hours of work are lost! I know it has happened to me before.

Of course, it is important to save, save, and save again. Using **Ctrl-S** should be a habit but honestly, when you are in the middle of a project and you get very involved, it is very easy to forget to save. "I'll save just after the next effect", and then ... bang... it is gone. Lucky for you, PaintShop Pro has an integrated auto-save option: **File > Preference > Autosave** settings.

It is recommended that you save your work as soon as you start it so PaintShop Pro has an actual saved file to update. There is a free script that can do that for you; it is called Open as a Copy[18]. It will prevent any save to overwrite an original image. So even if you have nothing new on your project, save it so you can give it a different name and PaintShop Pro will save it as often as you set it for. Starting with version X5, the **Autosave** offers you the option to save also all the open files on your workspace. If you choose that option it takes a little bit more time to auto-save, during which you have to stop working (you will see the progress bar at the bottom of the screen), but isn't it worth it instead of losing everything? Set it once, and then, you can forget about it!

[18] https://creationcassel.com/copy/

The older versions of PaintShop Pro had this dialog window for the **Autosave** setting where you were given the option to use the **Autosave** or not and the delay between saves:

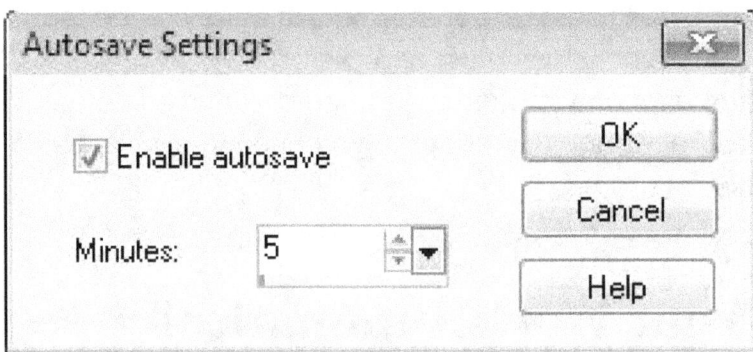

In PSPX2, Corel introduced **Auto-Preserve**, which will creates copies of the original files, instead of overwriting them (which could be quite inconvenient wouldn't it?).

In PSPX4, the **Autosave** is combined with **Auto-Preserve,** so don't look for it as a separate setting. You are given the option to also auto-save in the **Adjust** workspace and not just the **Edit** one.

In PSPX5, **Autosave** reappeared as a separate setting, and to this day, still is available to you. At this version, you are also given the option to save all the images on your workspace, or not. You are also given the option to adjust the **Autosave** settings differently for the **Manage** workspace and the **Edit** workspace.

Get the Right Unit

Some people work with inches, others with pixels, others with centimetres or even points. You can work in any of those units. If your PaintShop Pro is using one specific unit and you would prefer another one, just change it **in File > Preference > General Program Preferences** and in the **Units** tab, just pick your preferred unit and apply. Easy.

Now, all your windows will display the same units, whether it is the **New File** window, the **Resize** window, etc.

Note: whatever unit you choose, if you ever want to check **Image Information** for a PNG file, it will always display in metrics. This is a specific setting of PNG and cannot be changed.

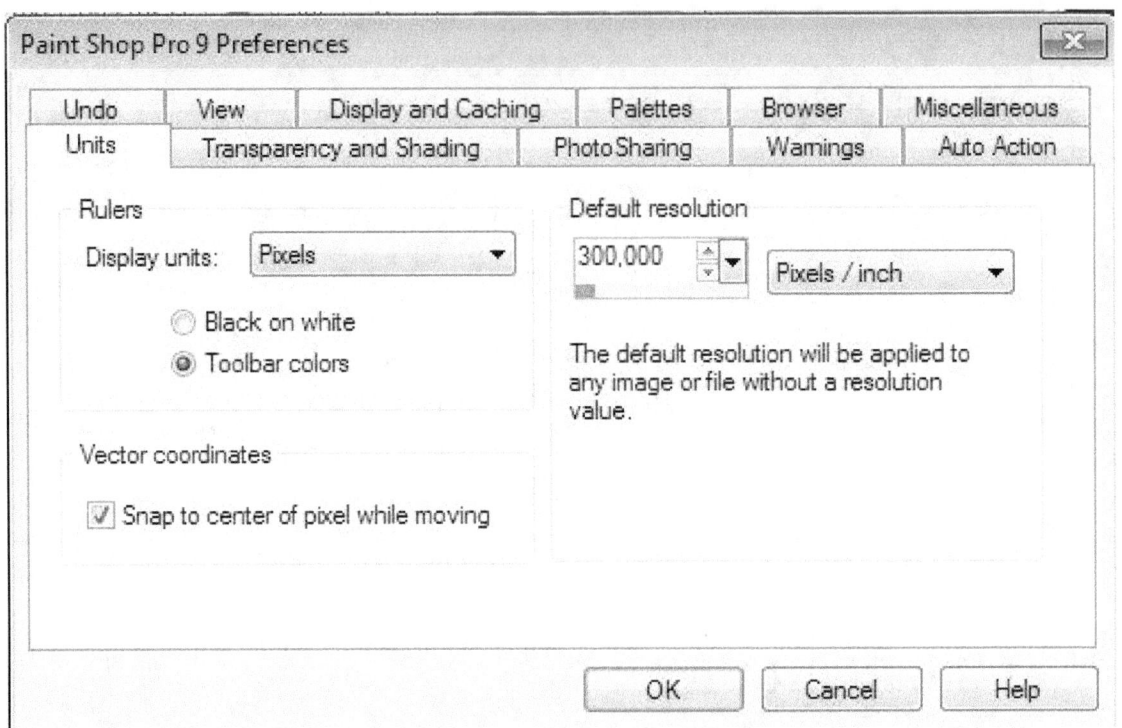

For PSPX4 and above

Although the current **Default** resolution is 300 ppi, older versions of PaintShop Pro had a default setting of 200 ppi. If that is what you are using,

you can change it to 300 ppi. And it will stay at that value for all your projects.

Skip the Warnings

PaintShop Pro is often trying to protect you from messing up with some commands. For example, if you are trying to close a file and had not saved it, it will ask you if you are sure. Although this is great to avoid costly errors (imagine closing a file you have worked on for hours without saving!) sometimes, there are some commands that you KNOW better and you are tired of those "unnecessary" warnings. For example, when you want to delete a layer, do you NEED that warning all the time? If you have SOME warnings that you can really do without, you can deactivate them in **File > Preferences > General Program Preferences** and under the **Warnings** tab you can UNcheck those warnings you can do without. Be careful however in which ones you will disable!

Automatic Actions

When performing different actions and executing commands, you will often get some warnings. I am not referring to warnings about whether you are sure you want to delete a layer, or close an image without saving, but a warning that the command you are trying to execute cannot be done in that stage and needs another step before continuing.

You can adjust your preferences to let PaintShop Pro always perform those intermediate steps for you (saving you time), or prompt you when they are needed. Go to **File > Preferences > General Program Preferences > Auto-Actions**. Choose your own set of auto-actions, decide which ones you want to be prompted for and which ones you want PSP to do without asking.

Thumbnail Size

In the old JASC PSP9 and previous versions, the layers palette didn't display any thumbnail of the layer content. With PSPX, it was added so you could see it directly instead of having to hover over it and wait until a little image popped up. Well, if you want the thumbnail to be bigger than it is by default, you can change that. If you prefer NOT having any thumbnail

because it makes the layers take too much space, you can change that too. How? Simply go in **File** > **Preferences** > **General Program Preferences** under the Palette tab, to the right, you can check or uncheck **Palette Thumbnail** and you can change the size right there too.

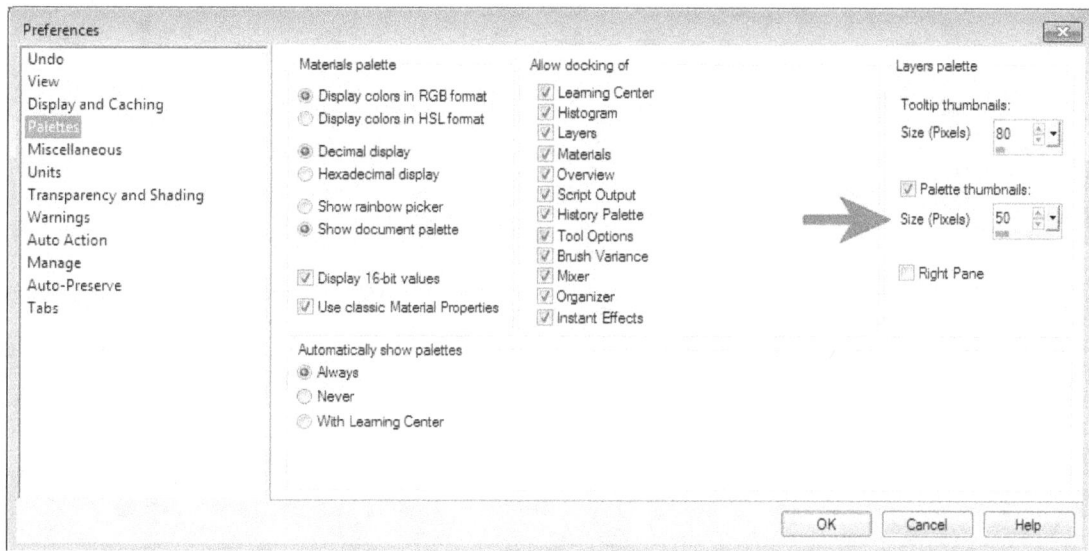

Did you ever know that? Will you change that or keep it as default?

Remove the Splash Screen

Although the splash screen is usually going in the background while PaintShop Pro loads, you always have the option to NOT display it when you start your PaintShop Pro. Simply go to **File > Preferences > General Program Preferences > Miscellaneous** and UNCHECK the "**Show splash screen when application starts**". And that's it!

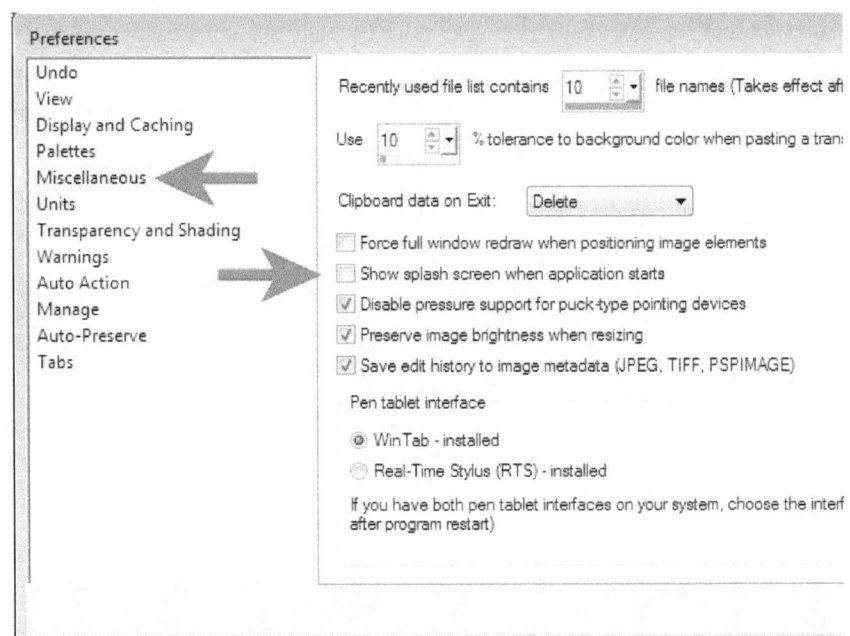

Edit Right From the Start

In some versions of PaintShop Pro, you have several tabs and by default, your PaintShop Pro could open in the **Manage tab**. In recent versions (2018 and above), it would start at the **Home** screen. It might take only one click to change it and go to the **Edit tab** but you can save yourself that ONE click by changing your preference. Simply go with **File > General Program Preference** and under the **Default Launch Workspace**, select "**Edit**". It's that simple. Now your PaintShop Pro will always open in the **Edit tab** (assuming you are mostly using that tab).

For PSPX4 to PSP X9

For PSP 2018 and up

Technical Considerations

As well as your PaintShop Pro works, you might encounter some issues. Typically, they are not bugs or malfunctions of the program but often one of the multiple settings that might go unnoticed.

Do You Have a Tablet?

Do you know that the **Brush Variances** can take into account the pressure you apply on your graphics tablet? Press harder and you can get a thicker line. Press lightly, and you get a thinner line. You don't HAVE to use that option if you want an even design, but it is still there if you want to use it. If you do have a tablet and you find that sometimes, your brush is not behaving properly, check the brush variance. It is possible that because of your tablet, the **Thickness** is set to **Pressure** by default. A little annoying if you don't use that feature though.

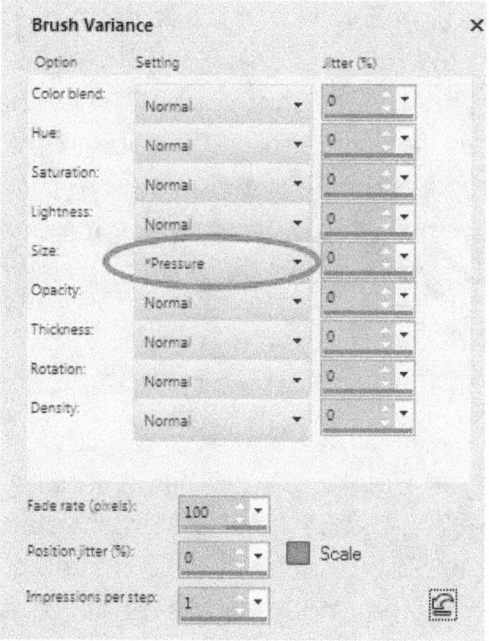

Open PDF Files in PaintShop Pro

Did you know that PaintShop Pro can open pdf files? This means that if you get some nice or fancy text in a pdf format, you can open it in PaintShop Pro. How cool is that to add either journaling or some text in the background?

Up to version X5, you will get each individual page as a new image in your PaintShop Pro (which could be resource-intensive), however, from PSPX6 until version 2018 it will only open the first page so it might be more convenient if you are opening single-page documents only. But it is now back to functional in recent versions.

Upgrade or Overwrite?

Are you still using an older version of PaintShop Pro? Are you considering upgrading but are afraid of getting lost in new tools and functions while you are already efficient with your current version? Don't worry. If you want to upgrade to a newer version EVEN if you decide to purchase the UPGRADE (as opposed to buying the full version), PaintShop Pro will NOT overwrite your current version. That means that you will STILL have your older version, the one you are familiar and comfortable with. That also means that if a new tool seems to be intimidating you, or you have a hard time finding the usual tools, you can always go back to your older version. It will still be there for you. Do you want to upgrade to a newer version? Go for it!

32 or 64 Bits?

If you purchase a copy of PaintShop Pro since version X6, you will notice that it includes both a 32 and a 64-bits version. If your computer is only a 32-bit machine, only the 32-bit version will be installed, but on 64-bit machine, both will be recommended. However, if you are using a lot of old plugins, you might find yourself reverting to using the 32-bit version more

than the 64-bit one. So why keep the 64? Because some newer plugins ARE made for 64-bit, and if you are not using those old outdated plugins, the 64-bit version will run faster and smoother. Don't worry, they coexist very well together! You just can't have them OPEN at the same time.

See What You Paint

Depending on the settings of your PaintShop Pro, you might find yourself guessing where the brush will print, or how big it is. If you want to "see" your brush before it is on your canvas, make sure that you have checked the box for it. You can find it in **File > Preference > General > Display and Caching** tab, check the box **Show Brush Outline**. This will take all the guess work out of the game!

Print Template

If you need designs in multiple copies, as if you used preset labels in a text editor, you might think that the easiest way is to copy and paste the merged image several times, align them where you want them and print. There is another way. You could choose ONE design (even unmerged) and in the **Print layout**, you can choose a readymade template! Yes, many of those standard templates (like Avery) for cards, labels, and such are all available in the **Print layout**, under **File > Open Templates**. Imagine the time you will save when you get to make multiple name tags, or Christmas gift tags!

Drag and Drop (1)

With PaintShop Pro X6, did you notice the ability to drag and drop from the tray onto the layer palette? And it will also rename your layer based on the file name you dragged! This is perfect for credits or to remember which element came from what source.

One little drawback though, is that the new element will automatically be placed on the very top of the layers, so if you needed it below, you will have to slide it down manually.

Lucky for you, in PSPX7, the image will be added just above the active layer. This is much more convenient!

Since you don't have this feature on your older PaintShop Pro version, you can always use the Open as Layer [19]script, that is free in the store.

Drag and Drop (2)

If you find an image while browsing on your **Windows explorer**, and decide which image you want to open or what paper background you want to use, you don't have to remember which one it is: simply click on it, drag it to the PaintShop Pro icon on your task bar until PaintShop Pro opens and drop it on the workspace. Even better, it will keep the name of the file intact!

General Program Preferences

You know that area of your PaintShop Pro where you can set various preferences, like the units for the ruler, the size of the thumbnails, whether to let PaintShop Pro perform some automatic actions, and more. You also know that you can access that area with **File > Preferences > General Program Preferences**. Do you know that you can access this in ONE single click instead of that long route? Check out the bottom of your **Layers** palette (in PSPX4 and later). Look for this icon:

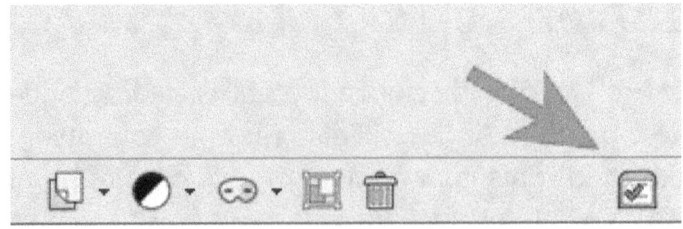

[19] https://creationcassel.com/layer/

Did you ever notice that little icon before?

To Keep or Not to Keep

Do you have older versions of PaintShop Pro installed? Are you using the resources that come with those older versions? Are you keeping those old versions ONLY for the supplies? If you want to get rid of the older PaintShop Pro versions but you still want to keep access to those extra brushes, tubes, etc. you can always copy them to another location and THEN uninstall those PaintShop Pro versions. If you don't use it, you can delete it.

Automatic Rotation of an Image

Since a few versions, PaintShop Pro will determine if your photo was taken with the camera (or phone) vertically (portrait) or horizontally (landscape). That is based on the EXIF of your image if your device keeps that data. Although it could be convenient to have the image automatically rotated, sometimes, you might not need it and it becomes an annoyance. If that is the case, you can disable that function with **File > Preferences > File format preferences** and uncheck **Rotate images automatically upon opening using EXIF data.**

Picture Tubes on a New Layer

Recent versions have allowed users to create picture tubes on their own layers. This is great if you want to click a variety of single image tubes, but it could be an annoyance when using other types of tubes. Even worse, it can prevent some scripts from working correctly if they involve picture tubes. So unless you specifically want individual layers for individual tubes (which could mean a lot in some cases), keep the "**Create as new raster layer**" unchecked as it should be by default.

Older Plugins

If you search for plugins online, you might find a bunch of them that are old, very old. Although it is possible that they won't work with newer versions of PaintShop Pro, it is also possible that they will still work. Typically, however, those plugins will work with the 32-bit version of PaintShop Pro (as 64-bits machines didn't exist when the plugins were created). Give them a try. And remember that if you find plugins advertised for Photoshop, sometimes, they still work with PSP, even if it is not mentioned. If they are free or if you already have them (maybe you also have/had Photoshop), give them a try in PaintShop Pro! You might be happily surprised.

What Is the Active Image?

Sometimes, you might have lots of images on your workspace and you want to know which one is active. This might be a problem if you are not using the tabbed windows mode. Although you could look in the layer palette to see the content of the active image, you can also go with **Window** menu and see the list of images at the bottom of the pull down menu. The one with a checkmark is the one active.

Note: The list of images has been removed from PSP2018 but it came back with PSP2019.

Missing List of Images

In PSP2018, you might have noticed that the list of open images under the Window menu seems to be missing. How can you choose one of many open images? Or see if one image is open? Look on your taskbar where the icon of your PaintShop Pro is, click on it and a list of the open images will be listed. Just pick the one you want to activate and you are done!

Scanning Photos

If you are scanning a photo, it is always recommended to scan at AT LEAST 300 ppi resolution. If you can do it higher, it is better. A higher resolution will NOT fix a grainy photo or add details that are not visible. The main advantage of a higher resolution is that you will have more pixels to "work" with. Of course, you can then also print a larger version of the image, but again, it won't fix the graininess or the blur!

Enlarging Photos

Enlarging a photo a lot (like more than 150%), it will typically lose quality and give a blurred image. If you still want to use that photo because it is meaningful to you, you can blend it into the background with a texture (either use a blend mode or by reducing the opacity). The added texture will

likely distract from the blurriness and you can still showcase your small picture.

If needed, you can also use **PhotoZoom** that is a good program to help enlarge photos with better results than just a straight enlargement.

Dual Monitors

If you have two monitors, did you know that you can place the various palettes on one monitor and leave the largest workspace on the other one?

Troubleshooting

Most of the times, your work will go smoothly, but there are times you will notice that something is wrong, or the program is behaving oddly, or a tool seems to be giving an unexpected result. Don't panic. Sometimes, one of the settings is just wrong, or has changed accidentally and you simply get a bad surprise. Nothing is lost. Let's look at some elements you might need to check.

Cut Off Fonts

Someone once mentioned she had issues displaying some long fancy fonts in her PSP, as the "tails" were cut off. When I checked, it worked fine in my PSP2018, but I noticed that it was also cut off if using my old PSP9. So, why does that happen? I still have no idea, but if a stroke is added, then those tails will appear. Of course, adding a stroke might make a font too thick, but did you know you can add a 0.1-pixel size stroke? That will barely thicken the characters but will allow those tails to show properly. Strange, I know, but if you notice that issue, try that solution!

Oddly Shaped Dingbats

Are you using a dingbat symbol and it looks wonky? Is it only when you are placing it on a path while it looks ok if it is on its own?

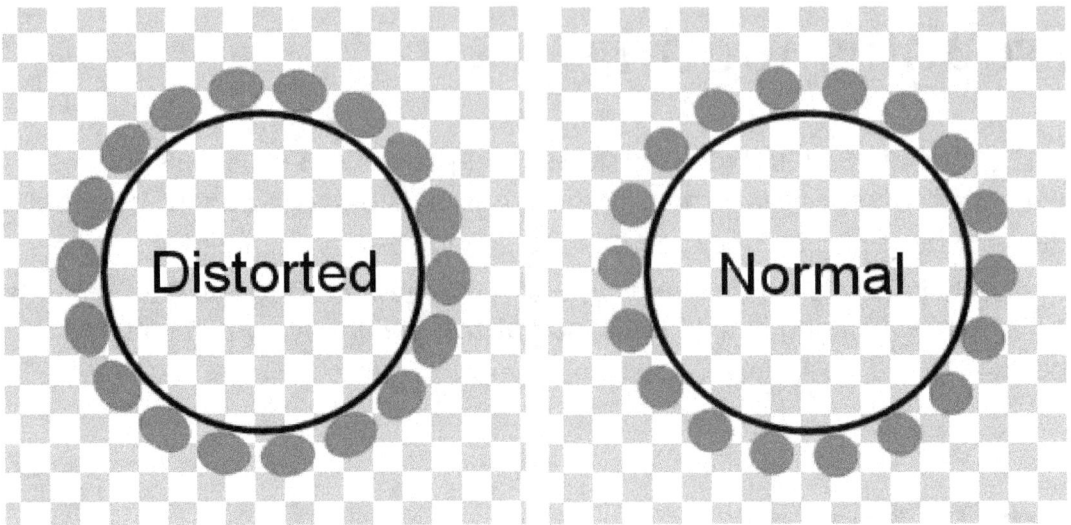

If so, check in the **Text** tools settings, and find the **Warp Text** option: it might be checked, so uncheck it.

That is a little obscure checkbox in the **Text** tool option bar, so you might have to search a bit.

Script Error

Scripts are codes that use PaintShop Pro tools and functions. This means that if a bug appears in one version of PaintShop Pro, it could affect some scripts. It is not common, but it can happen. There is also a possibility that the scripter didn't think of one particular situation that will cause an error. If you ever experience an error in running a script, first refer to the README file in case there are some special instructions or special supplies you needed to save in the proper folders. If that does not solve the problem, email the scripter. Include a COPY of the red error that will appear in the **Script Output Palette** (not a screenshot). The whole error message will give indications as to what command fails, possibly the reason AND the line number. That is essential in helping to fix the code as it can include thousands of lines of code and without that line number, it will be much harder to pinpoint the issue. Yes, errors DO happen, but the authors should usually be able to fix it for you.

Disappearing Images

If you are using a graphics tablet, you might have noticed that occasionally, your images all disappear from the workspace when you accidentally drag your stylus on your workspace while holding one of the buttons, yet, they are still in existence since you can "see" them listed under the **Window** menu (except in PSP2018). The only way I discovered the images could be retrieved is to go to the **Window** menu and check the **Tabbed** option, then uncheck it. All your images should reappear. This behavior can happen with any version.

Sudden Odd Behavior? Reset to Default

I hope it never happens, but if, at any point, you find that PaintShop Pro is no longer playing nice, behaves oddly, crashes seemingly without a reason, and you cannot figure out how to fix the issue, you can always reset it to default: close PaintShop Pro and re-open it by double clicking on the

desktop icon while holding the **Shift** key. It will ask if you want to revert to default (or words to that effect) and you should click OK.

After that, check its behavior, and if everything works fine, reload your saved workspace (you saved one before, it started misbehaving, didn't you?) It can be definitely annoying to have to reset all your **File location** and **Program preferences**, but if it fixes the other behaviors, it will be all worth it since you would now have a functional program.

New Patterns and They Are Not There

Occasionally, when you purchase a script, there is a pattern included in the zip file. You are asked to put it in the **Patterns** folder and then, you run the script and you get something weird: the pattern is NOT used in the script as expected. What happened? You didn't do anything wrong, but it seems that sometimes, PaintShop Pro does not realize that you added those pattern files. It is a bit like it was out for a break when you put them there, and it didn't see you.

If this happens, go to your **Materials palette**, click on the swatch and find it in the drop down list (of course, if you don't see it, it would mean you didn't put them in the right place!). Usually, that seems to be enough to remind your PaintShop Pro that those patterns ARE THERE! And you should be good to go after!

Lost Settings

Usually, your toolbar will appear just above your workspace, but if your PaintShop Pro window is sized down, or if you are using a tool that has a very long toolbar (like the **Text** tool), you might wonder where all your settings are. Don't worry, they are there, but PaintShop Pro is kind of layering them instead of squishing them. Look for a tiny arrow pointing right on your toolbar and click on it. You will see more settings appear (ok, it will

hide others in the process), so you can adjust them. The **Text** tool can have up to 3 of those little arrows, if your window is small. But everything is still there!

Starting with PSPX9, several settings have been grouped into one dropdown window, and you can find it here:

Trusted Scripts Location

Did you ever try to run a script that was saved in the **Trusted scripts** folder, but when you run it, you keep getting the message that it should go... in the **Trusted scripts**, then you get puzzled. Isn't that exactly where you saved it in the first place? One detail to check is your **File Locations**. Maybe you have one copy in both the **Trusted** and the **Restricted scripts** folder because PaintShop Pro will check the Restricted scripts folder first and if it finds the script you are trying to run, it will use that version and not check the other folder. If that is the case, you might just get that error message. Also, make sure that the actual **Trusted scripts** folder is not pointed to by the **Restricted scripts** tab as a file location. Double check that and you might find the solution to the error message.

Odd Behavior of the Brush Tools?

The **Brush** tools takes the colors from the **Materials** palette, but it also takes note of the **Texture** set for the background, whether you want it or not, so if your **Brush** tool (**Paint brush, Eraser, Lighten/Darken**, etc.) seem to behave oddly, check to make sure you don't have a texture set for

your **Background**. Of course, once you know that, you might want to use it on purpose too as described in another tip, earlier in this book!

New Version and Missing Content

When you get a newer version of PaintShop Pro, you might find that you are missing some content you used to have. That might be because the newer version has different content, or it might be because you had accumulated supplies that are obviously not in the new version. Remember that you can get your newer version to use an older version content by simply pointing it to the correct folders. Simply go with **File > Preference > File Location** and choose each type of content (brushes, picture tubes, patterns, scripts, etc.) and tell PaintShop Pro where to find them.

Lucky for you, since version 2019, PaintShop Pro has a new feature that allows you to automatically import the content from your previous versions. Go to **File > Import > Content from previous versions**. This will set the **File Location** for the current version to point to those set in the previous version, saving you a lot of time!

Where Are the Nodes?

When you work with vectors, you probably want to use the nodes to tweak the shape. Are you sometimes looking for those nodes and they are not there? If that is the case, look if the **"Show node"** box was checked or not. Even if you already drew your shape, checking the box will make the nodes appear. With the same checkbox, you can make nodes disappear if they are present and are just annoying you in your work (if you don't need them).

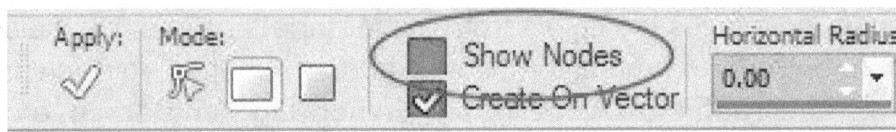

NOTE: this option is not available for **Preset** shapes, but only for **Rectangle, Ellipse** and **Symmetric** shapes and the **Pen** tool too.

Copy/Paste Not Working?

I very often use the copy and paste shortcuts (**Ctrl-C** and **Ctrl-V** or **Ctrl-Shift-V**) in PaintShop Pro, however, I have been frustrated with times when it just didn't seem to work. I could repeat the commands over and over and got NOTHING. I discovered that if the **Pen** tool is active, the **Copy** command works but the **Paste** command SHORTCUTS do not seem to work. Why? I have no clue but I know that if I am not getting anything when I copy and paste, I just have to activate any other tool than the **Pen** tool.

Missing Icons in X4 and Above

Are you currently using PaintShop Pro X4 or more recent and are missing the icons in the menu like you had in previous versions? They are not lost. They are just hidden. Although in version X3 you could get them all back with one command, in X4, get ready for a long task (it is easy, but looooooong). Go **View > Customize** and under the **Menu tab** you will notice that Corel apparently forgot the **Icon menu** they had in X3. However, you can recover the icons by clicking any menu element you want to use while the customize window is open, right-click on it and choose **Image and Text**. Unfortunately, you will have to do that for every command of the menus, one by one. Long to do, but very easy. As a suggestion, start with those you really do use and then, save your workspace!

Missing Icons in X3

Are you currently using PSPX3 and are missing the icons in the menu like you had in previous versions? They are not lost. They are just hidden. At that point, some commands have been somehow "archived" but they are

still in your PaintShop Pro. To retrieve them, simply go **View > Customize** and under the **Menu tab**, check **Menu Icons**. And voilà! They are back.

Not Enough Memory (1)

Do you sometimes try to move a large layer using the **Pick tool** (or **Raster Deform tool**) and get that dreaded message that it will take a large amount of memory and asks you if you want to continue? Although, sometimes, it might work just fine, I hate to risk ending with a "not enough memory" message or my program would freeze. Here is a tip on how to get around this situation: just use the **Move tool** instead. It is just less resource intensive than the **Pick tool**.

Not Enough Memory (2)

Just like when you want to move a large layer with the **Pick tool** and you get the "not enough memory" message, you can also get this one if you try to resize that layer using the same tool. The simplest way to get the task completed without freezing your PaintShop Pro is to resize the layer using the long way: **Image > Resize**, and resize to a more manageable percentage (don't use the pixel unit) and remember to uncheck the "**Resize all layers**" since you only want the change on one layer. Once the layer is

somewhat smaller, you might be able to fine tune the size with the **Pick tool** without it complaining.

Fill Tool Oddity

Are you trying to use the **Flood** fill tool and it does not seem to fill the whole area you want? Check out the tools settings and see if the **Use All Layers** is checked. That can really mess up the result when you are not expecting it!

Slow Brush

Do you sometimes want to use the brush tool and find it is taking forever to display the line you just drew? Check the settings and what is the step set at? One possibility is that the step is set very low. You rarely need to have it set to 1. Try to set it to 10 and see if it still gives the result you want. Sometimes, you NEED to set the step at 1, but maybe you don't really need it so check it out.

Odd Brush Behavior

With all the possible settings available for the **Brush** tool, there is often a chance that the last settings used are very different from what you are expecting the next time you use the tool. If that is the case, check the **Brush Variance** palette (**F11**) as it might need to be reset using the **Reset** icon on the bottom right of the window. Various changes in the settings on that window could lead to unexpected size or position jitters of the brush imprints. That can be surprising when you just want to draw a simple line or so.

Messed Up Menus

It is probably an accident but if your menus on the menu bar get messed up, some are missing, and such, you can retrieve them easily. Go to **View > Customize** and under the **Menu** tab, click **RESET**. Voilà! It is that easy and your menus are back to normal. Of course, if you had customized them in the first place, you might have to reset those manually.

Missing Palette/Toolbar

Occasionally, you might be typing something or simply touching your keyboard and suddenly, something disappears from your PaintShop Pro: a palette or a toolbar just vanished and you have no idea what you just did, so you can't UNdo it. Don't worry, you can retrieve any palette or toolbar that is playing hide and seek by going through **View > Toolbar** or **View > Palette**.

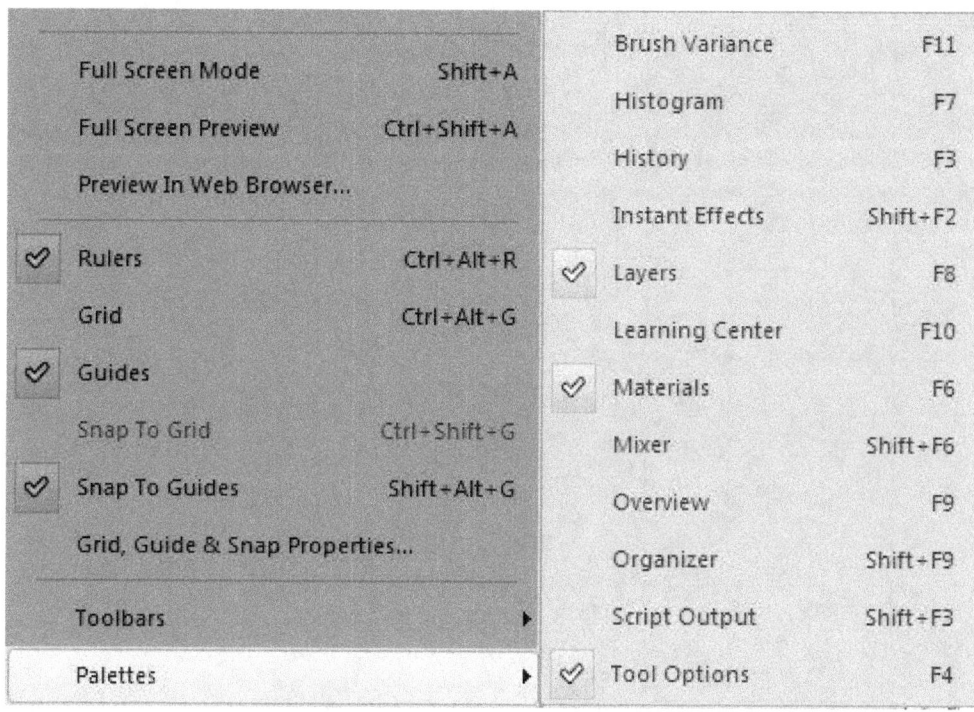

They can never hide too far!

Script Recording Issue?

PaintShop Pro allows you to record various steps you are doing in order to replicate them later for you. Beware that the script is... STUPID: it will repeat everything you did, even if it does not make sense. If you clicked on an element and moved it, it will click at the same place, even if there is nothing at that exact point; it will flood fill at a specific point that was used in the recording, even if this time, you would have preferred to have a click a few pixels further. So, be very aware that EVERYTHING you do will be recorded and repeated, no matter if it makes sense or not. So if you end up with a script that does something odd, chances are it is still doing what it was told!

Conclusion

PaintShop Pro is a powerful program that includes tons of tools and settings to be used for various projects. Whether you are a scrapbooker, a photo editor, a graphic artist or using PaintShop Pro for a variety of other projects, you are still using a lot of the same tools and commands, and you always want to work faster, more accurately and more effectively.

If you are interested in using your PaintShop Pro to start digital scrapbooking to capture, document and share special photos and moments with family and friends, you can visit the Campus and learn how to create your first pages, for free.

https://scrapbookcampus.com/qp/

Maybe you are not into scrapbooking. That is ok. If you want to find out more about PaintShop Pro, you can visit the Scrapbook Campus[20] (and it is not only about scrapbooking) and join our live monthly classes.

If you have any question about this book, about some of the tips or if you have more tricks that you would like to share, don't hesitate to email me at cassel@creationcassel.com

[20] https://scrapbookcampus.com

Credits

Brands and logos:

All the products names and logos used in this book belong to their respective companies

Photos and illustrations:

Carole Asselin

Blake Shimata for the cover design and photos

Unsplash:

- Mathew Schwartz
- Christian Bowen
- Andrew Small

Corel Corporation ®

At the time of printing, PaintShop Pro 2020 is the latest version available. Most of the screenshots were taken using that version, except when specifically illustrating previous versions interface.

Acknowledgments

Most of the tips included in this book have been discovered by me, but some of them came from questions from customers from the store, members of the Scrapbook Campus or even from various groups and forums. If anyone ever thought they were annoying me by asking questions when something didn't seem to work as they expected, you can see that it had a bigger purpose in the end. Thank you for trusting me.

Thank you also for my proofreaders, Bonnie, Michele and Lyn. After working for days and weeks on this document, your fresh eyes caught a lot of errors and typos that I could no longer see!

Special thanks to the Corel PaintShop Pro team for their assistance in the development of this book.

Index

3
32 or 64 bits .. 172

A
ABR files ... 156
Actions
 Auto-actions 166
Align ... 53
Anti-alias ... 19, 71
Auto-Preserve .. 162
Autosave ... 161

B
Background .. 143
Batch .. 79
Blur ... 135, 136
Border .. 77
Brightness .. 119
Brush 73, 183, 187
 Size .. 50
Brush Tip
 Calligraphy ... 32
 Rectangle .. 31
Brush Tips ... 21

C
Cascaded ... 87
Center .. 21, 46
Clone .. 49
Close .. 31
Color 131, 137, 142, 144, 145, 147
 Layers ... 118
 Multicolored Text 58
 Pick .. 39
Colorize ... 134
Connect ... 24
Contact sheet ... 97
Content ... 184
Copy Merged .. 105
Copy/Paste .. 185
Corners .. 74
Crop 33, 40, 43, 44, 46, 98

 Multiple layers 35

D
Dingbats ... 179
Drag .. 173, 174
Drag and drop .. 78
Dragging .. 30
Drawing ... 73
Dual Monitor .. 178
Duplicate .. 122

E
Edit
 Text .. 69
Edit a Selection 14, 16
Edit tab ... 168
Effects ... 149
Emboss ... 52, 135
Enlarging .. 177
Essential ... 100

F
Facebook .. 151
File Format ... 79
File locations ... 153
Fill 187
Flood Fill ... 49
Floodfill .. 23, 48
Font 61, 66, 67, 179
Fonts .. 58

G
Glow 140, 141, 142
Gradients .. 151
Grey ... 148
Greyscale .. 143
Grid .. 99
Group .. 115
Guides 36, 37, 38, 89, 90, 99
 Remove .. 38

197

H

Help ... 127

I

Icons .. 91, 185
Image .. 176
Image information .. 83
Images .. 87, 181
 Missing ... 177

J

JASC .. 152

L

Lines ... 72
Link .. 110
Lock ... 112

M

Mask .. 153
Material ... 138
Materials Palette ... 114
Memory .. 186
Menu .. 127, 128, 129, 188
Missing
 Palette & Toolbar 188
Move
 Move a selection .. 15
 Tiny Elements ... 25
 With precision .. 29

N

New layer .. 117
Nodes .. 20
Nodes .. 184

O

Opacity .. 23
Open .. 155
Optimizer .. 81

P

Paint .. 173

Patterns ... 136, 182
PDF .. 172
Pen .. 73
Pen Tool .. 20
Photoshop ... 151
Picture Tubes .. 175
Pinking Shear .. 29
Pixels ... 11
 Remove ... 75
Plugins ... 154, 176
Preferences ... 174
Preset .. 93
Print .. 173

R

Rename ... 113
Repeat .. 43, 105
Reset .. 21, 181
Resizing ... 13, 69
Resources .. 152, 156
 Save ... 157, 159
Right-click ... 103
Rotate .. 28, 42, 46, 51
 Angle .. 52
Rotation
 Automatic .. 175
Rulers ... 85

S

Save ... 80, 83, 98
Saving ... 69
Scale ... 13
Scanning ... 177
Script ... 181, 189
Scripts ... 157, 183
 Accented characters 97
Selection ... 121
 Freehand .. 40
Settings .. 182
Shadow ... 131, 132, 145
Shadows ... 134
Shape ... 67, 73
 Stellated .. 73
Shapes
 Preset .. 72
 Vector .. 72
Sharing .. 81
Shortcuts .. 99, 104, 106
Silhouette ... 146
Smooth .. 11, 18, 78

Space .. 124
Specks and Holes ... 76
Splash screen ... 167
Step ... 55
Stitching .. 120
Straight Lines ... 11
Straighten .. 25
 Perspective .. 45
Style
 Text ... 70
Sunshine .. 137
Supplies ... 152
Swatches ... 94, 96

T

Tabbed ... 87
Tablet .. 171
Template ... 173
Text ... 63, 66, 69, 85
 Filled .. 64
 On Path .. 64
 Save .. 60
 Vertical .. 63
Texture .. 57, 131, 133, 147
Thumbnail .. 122, 166
Tools
 Shortcuts ... 104

Tracking ... 20
Translucent ... 140
Transparency .. 112

U

Undo .. 109, 121
Un-erase .. 48
Unit .. 163
Unwarp .. 51
Upgrade .. 172, 175

W

Warnings .. 165
Warp Mesh .. 19
Watercolor ... 33
Watermarking ... 76
Workspace .. 86, 88, 100
Workspaces ... 93
Wrapped Text ... 69
Wrinkle .. 140

Z

Zoom .. 17

www.ingramcontent.com/pod-product-compliance
Lightning Source LLC
Chambersburg PA
CBHW081428220526
45466CB00008B/2302